ISRAEL

In the first segment, you will be witness to the journey through the streets of Tel Aviv, the inside of an Israeli settlement, into the Israeli side of Jerusalem, and past Israeli security checkpoints, encountering the Israeli Defence Forces.

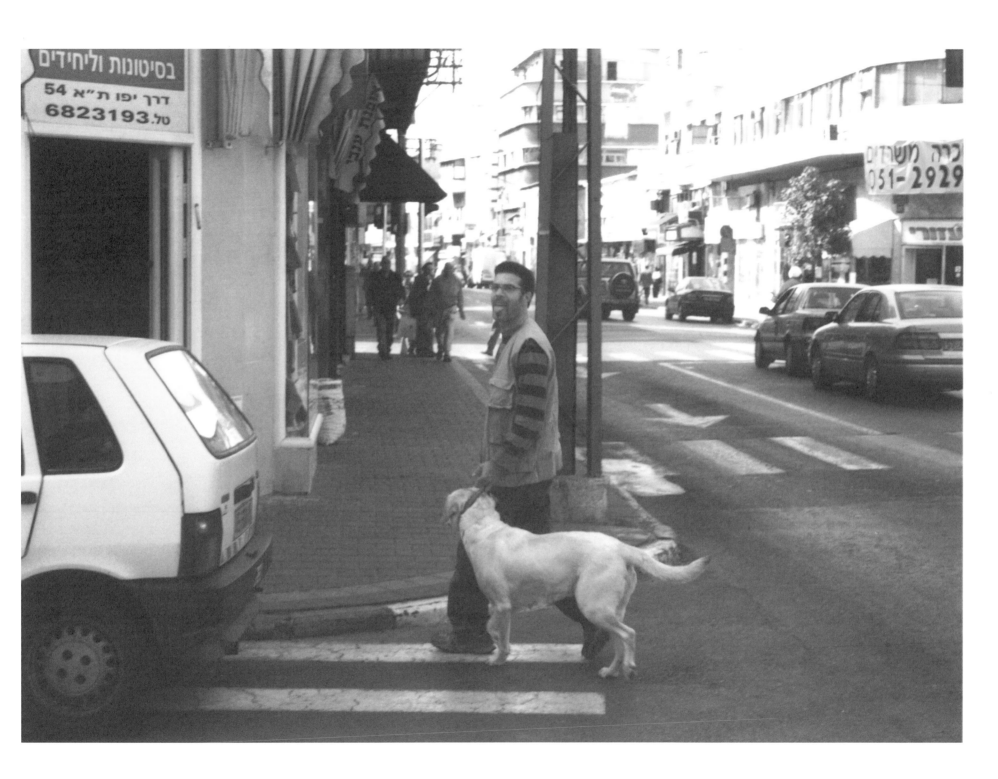

9

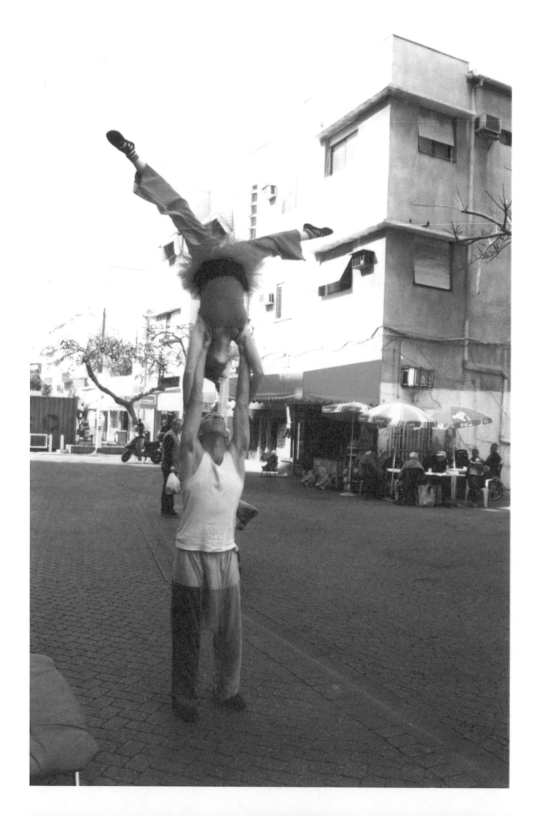

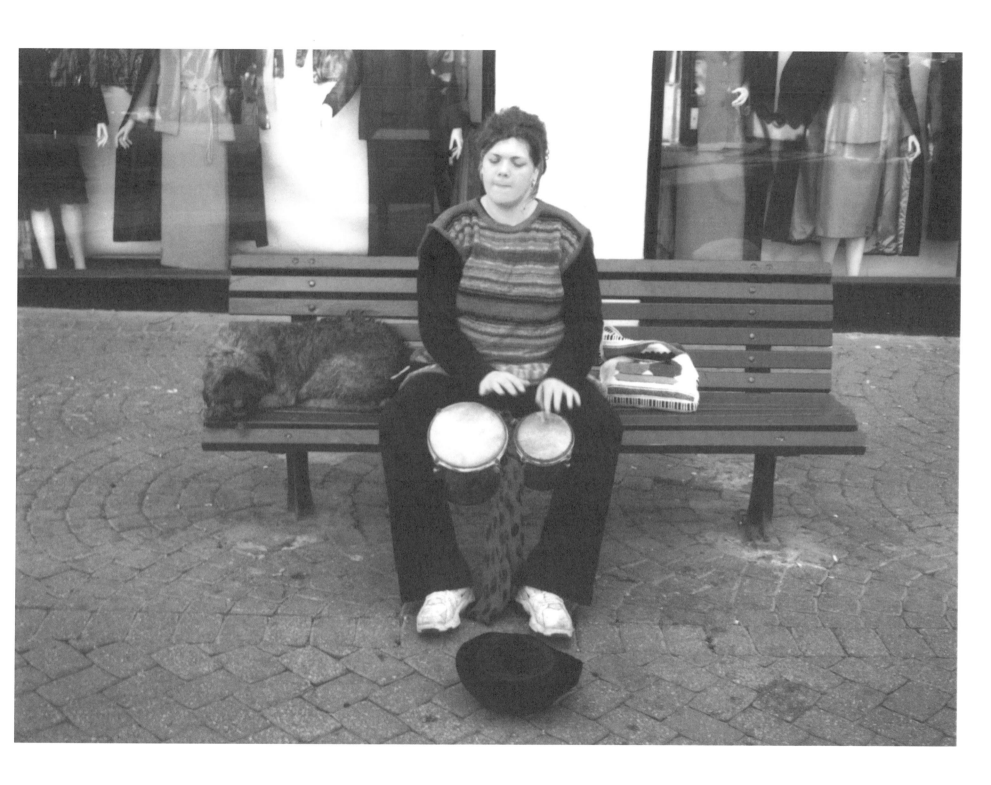

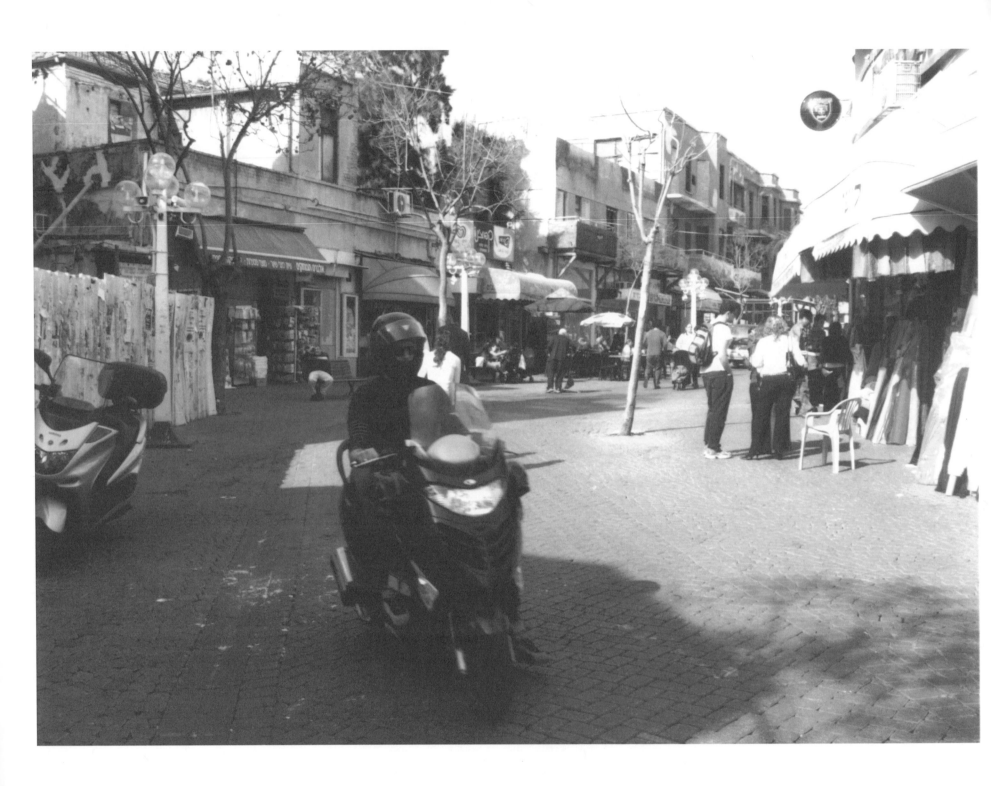

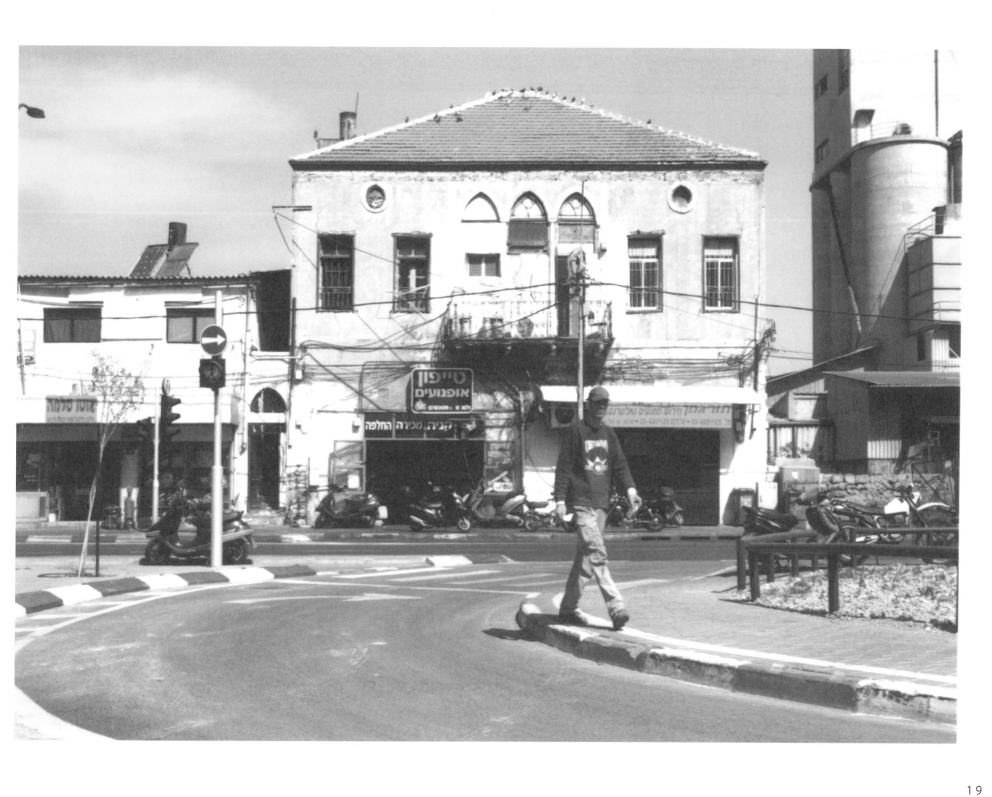

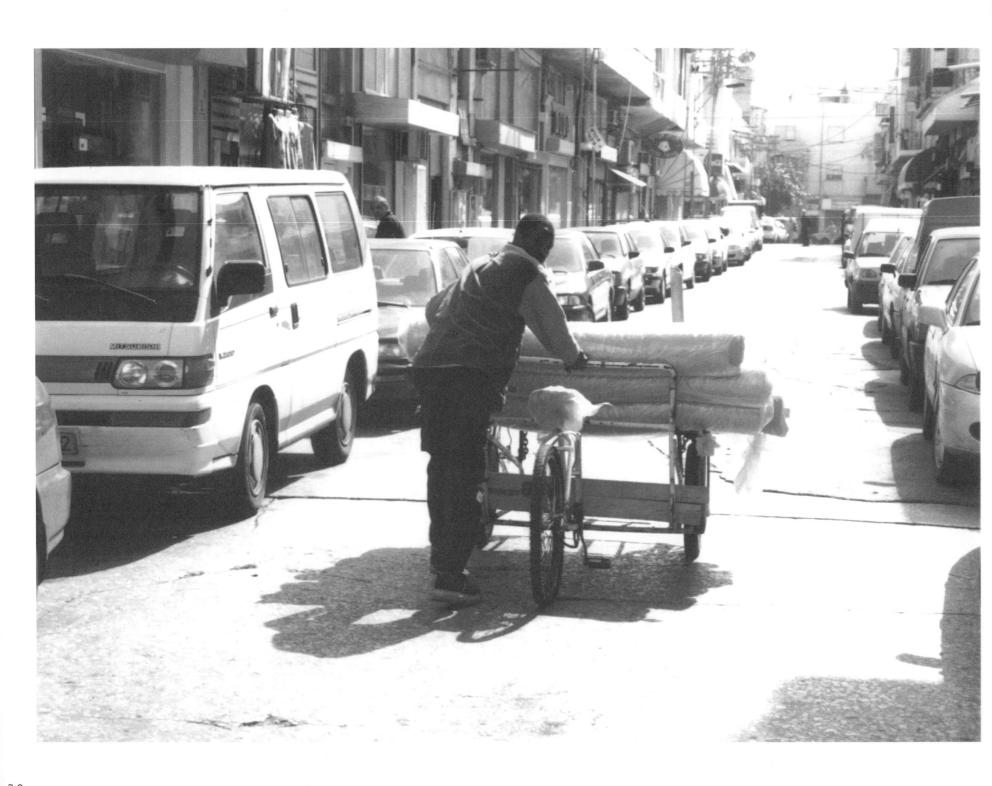

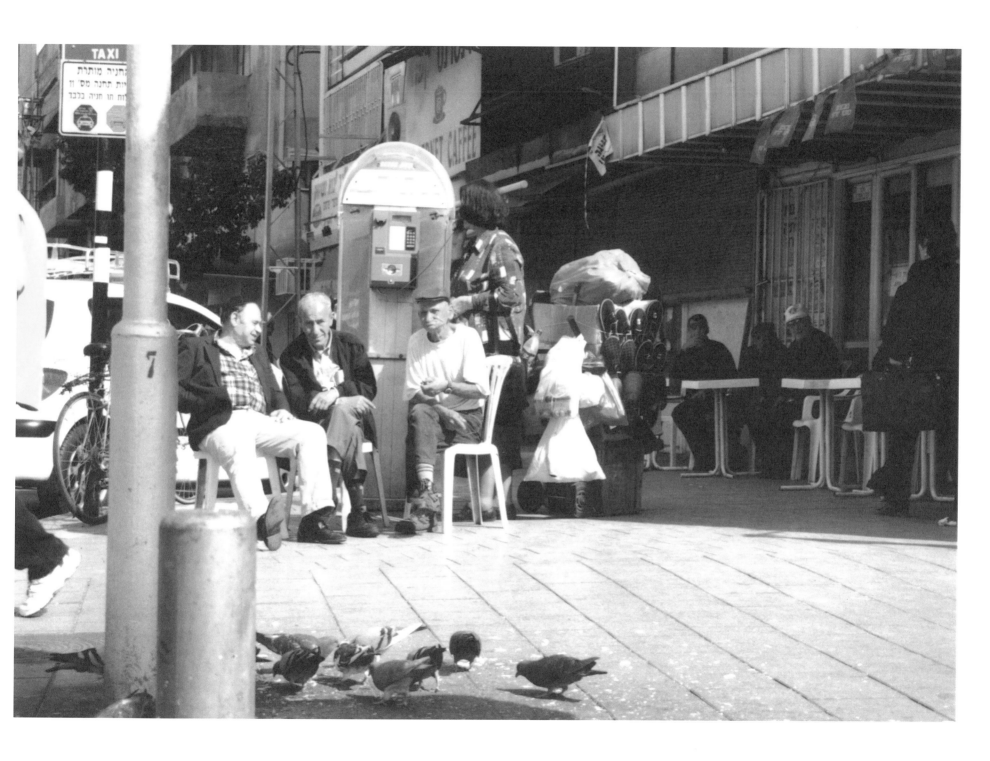

21

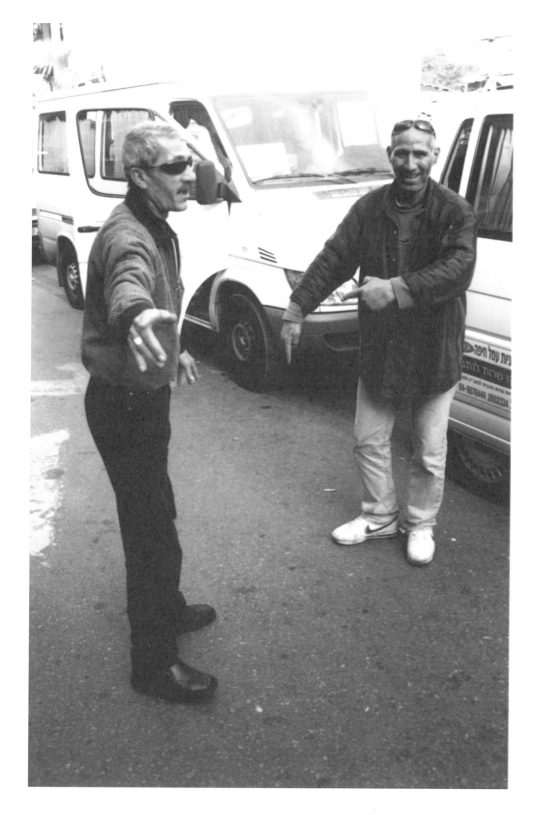

25

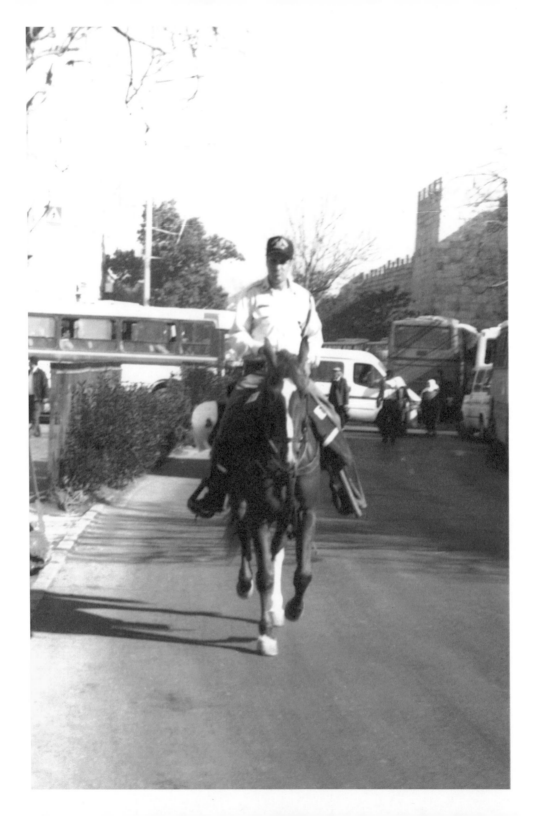

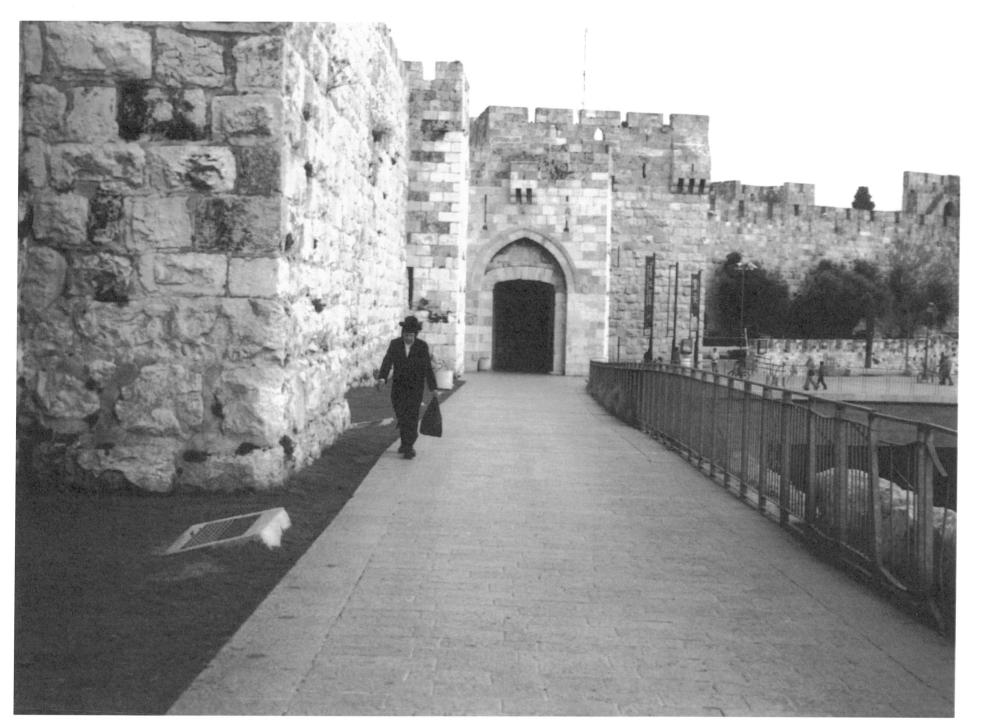

JERUSALEM

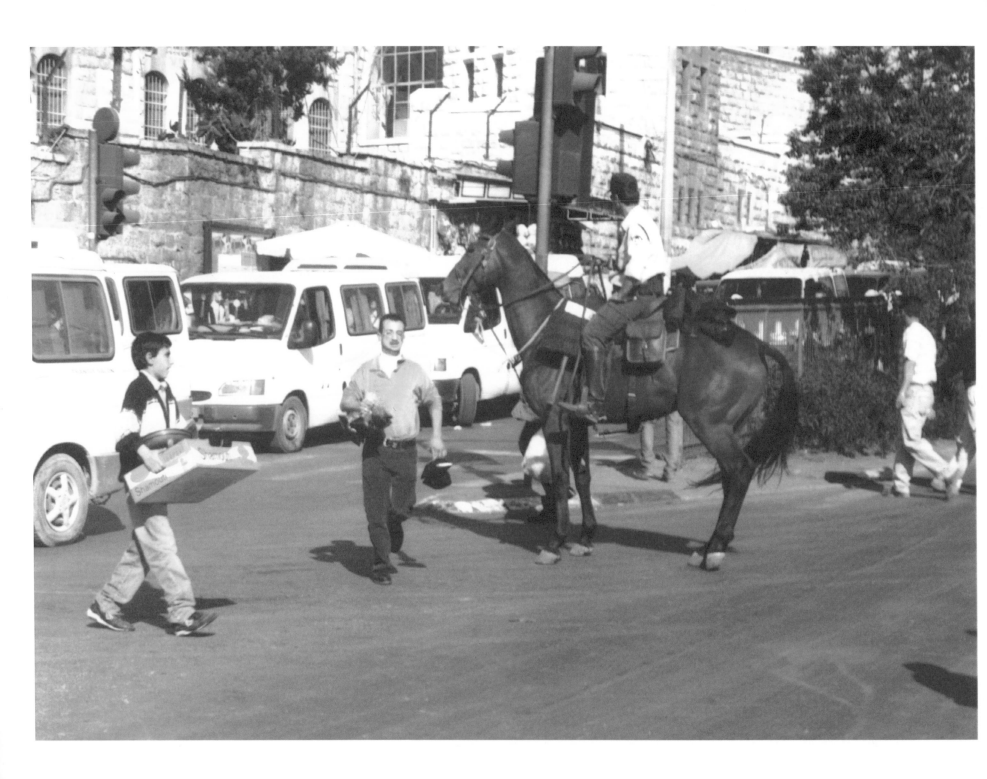

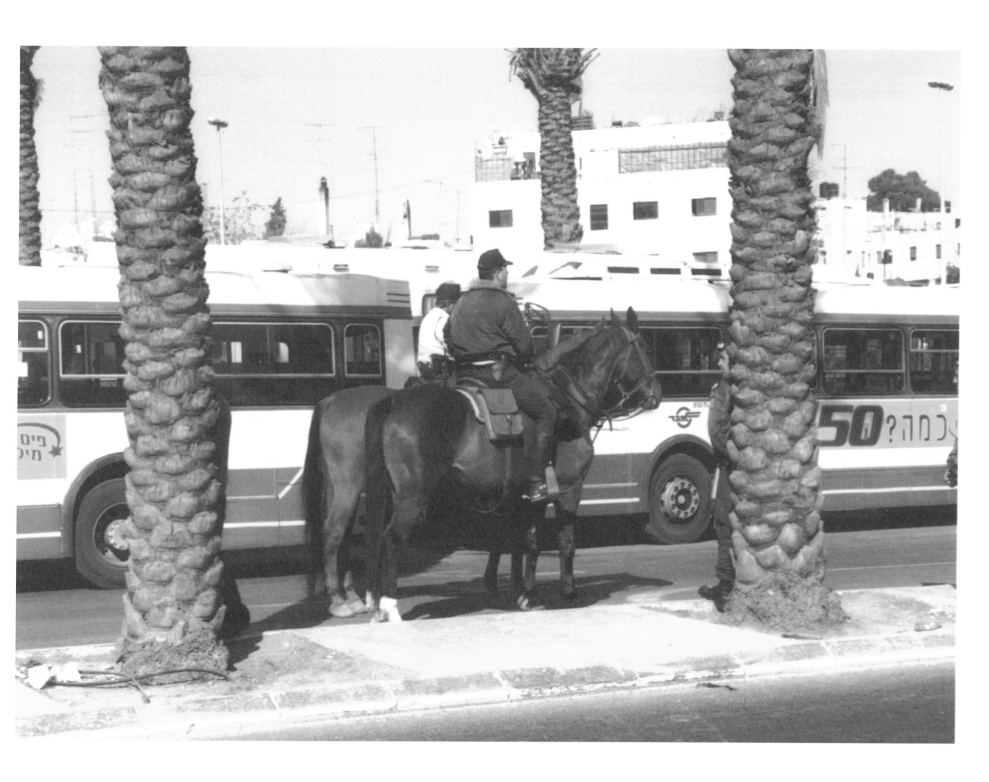

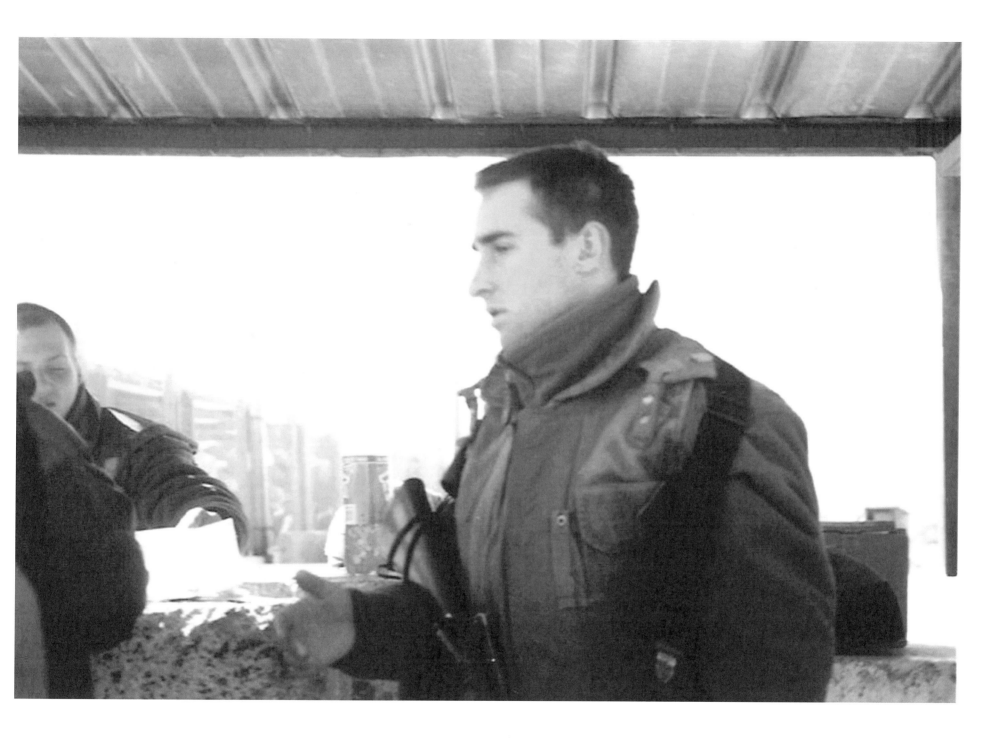

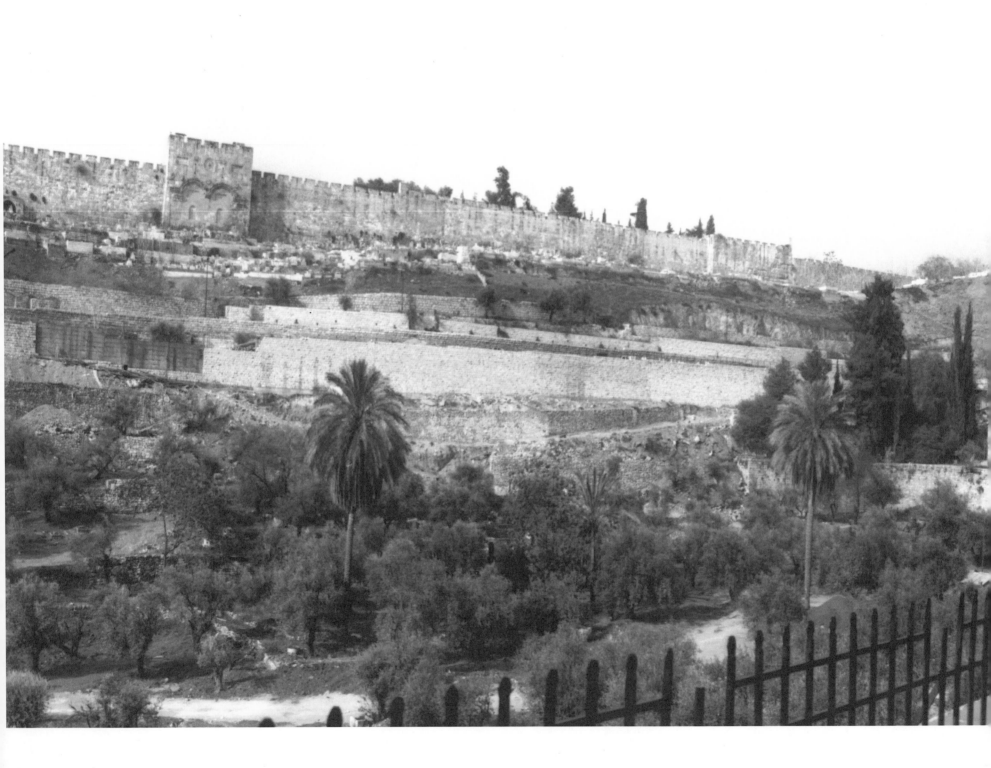

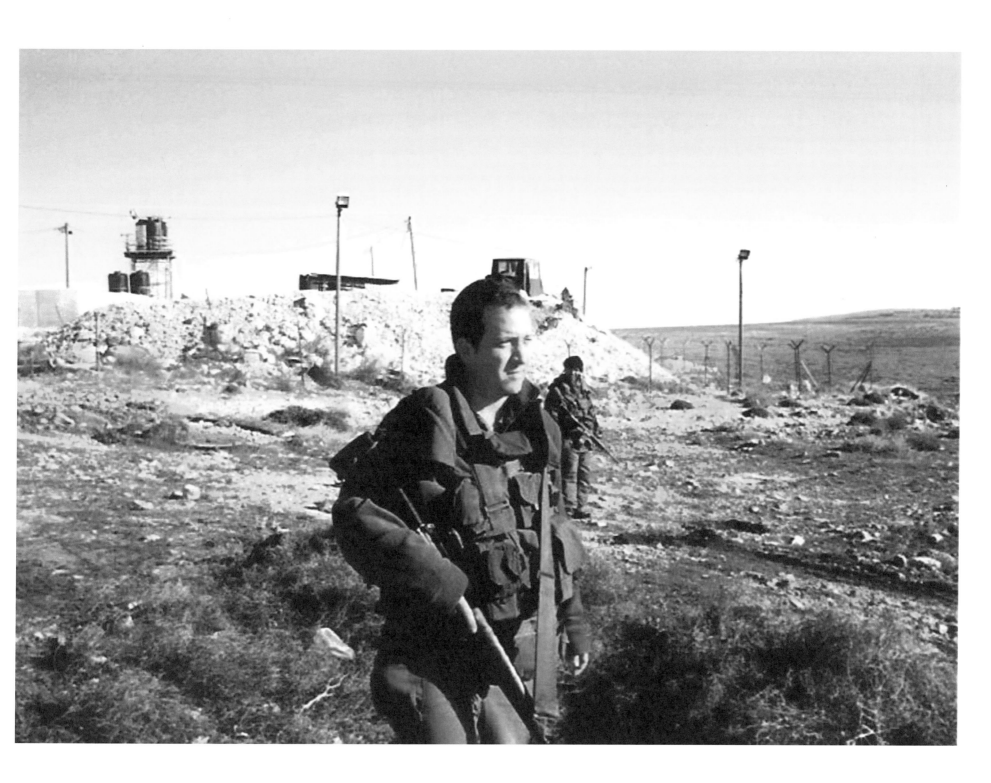

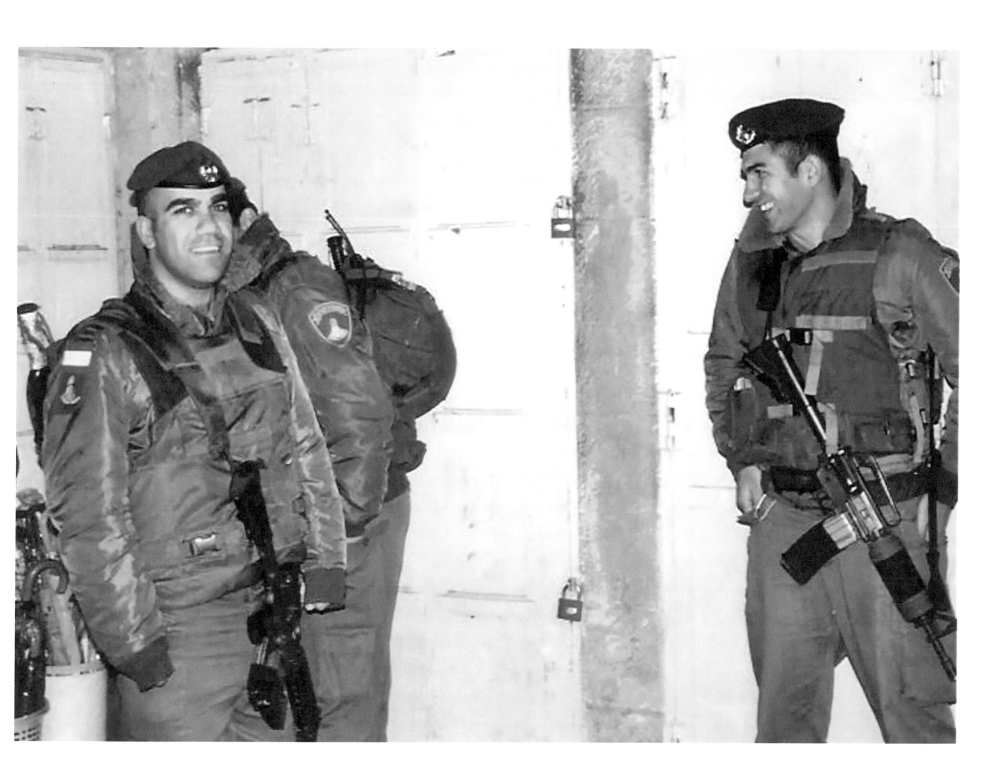

"What a fascinating start to our journey through my photo book, especially as we dive into the unique experiences I had while traveling through Israel and Palestine. The openness of the people in general, their willingness to be photographed, and the overall positive interactions paint a picture of warmth and hospitality. As we transition into the chapters covering the West Bank and Jerusalem, it's clear that the tone might change, reflecting the complexities of the region. The mere mention of entering these areas hints at a deeper exploration of cultural, historical, and political nuances.

I'm ready to embrace the stories that unfold and to witness the power that my photographs hold in capturing the essence of these places and their people. The idea that, despite differences, a smile has the power to connect us all is truly incredible.

I transcend cultures, and beliefs, serving as a universal language. If you're ready, let's continue this journey and explore the next chapter together. My unique perspective and the stories my photographs tell are sure to make this journey unforgettable."

- SALEEM THIAB, AUTHOR/PHOTOGRAPHER

PALESTINIAN CIVILIAN WITH IDF SOLDIER.

In this particular photograph, the atmosphere is somewhat tense, as one individual seems
noticeably uncomfortable being there. In the late 90's although the conflict was still occurring it
was not as intense as it is today, for example, these days you would not see a Palestinian and an
IDF soldier playing around.

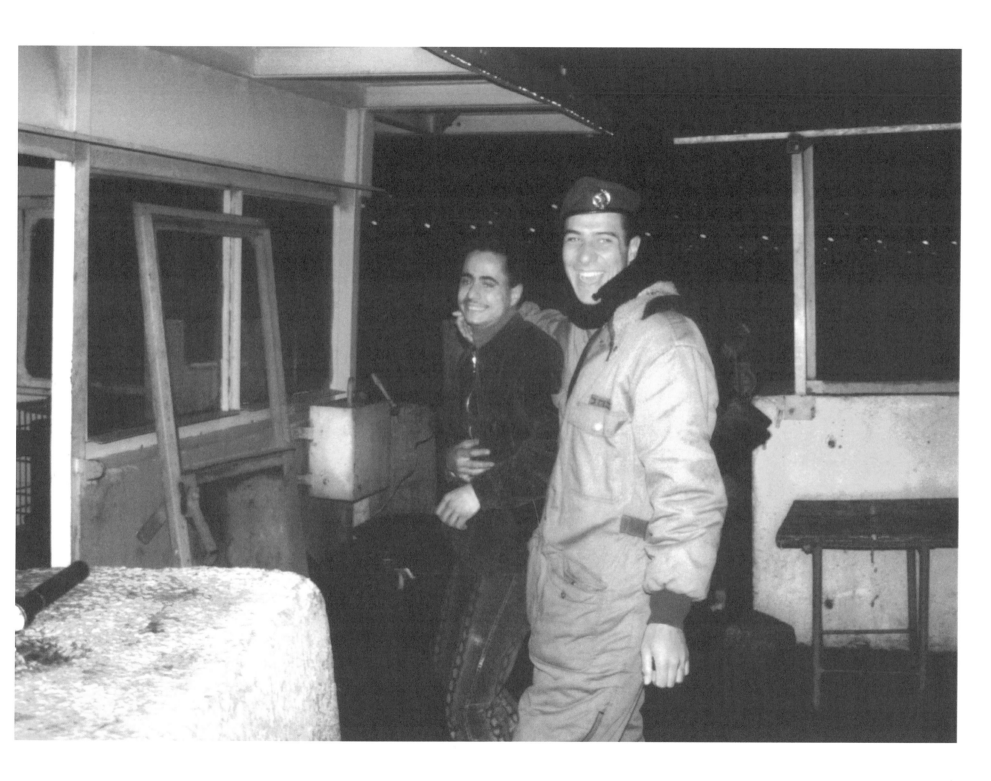

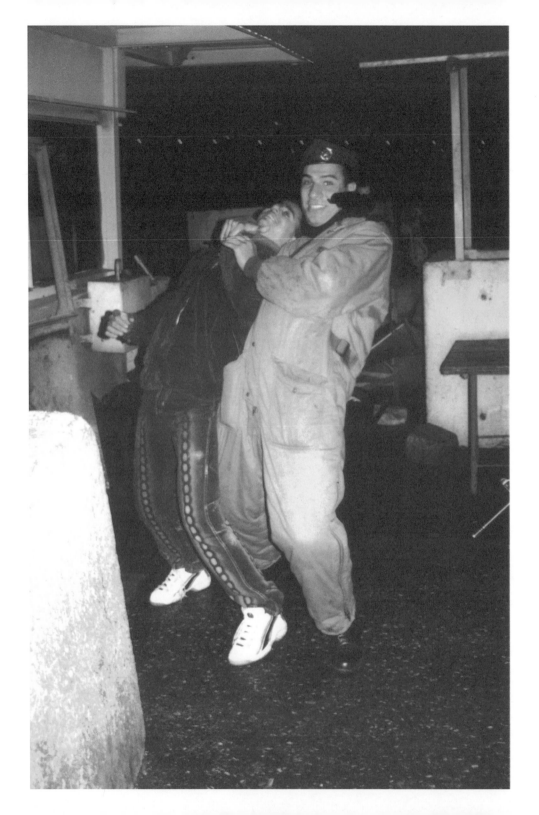

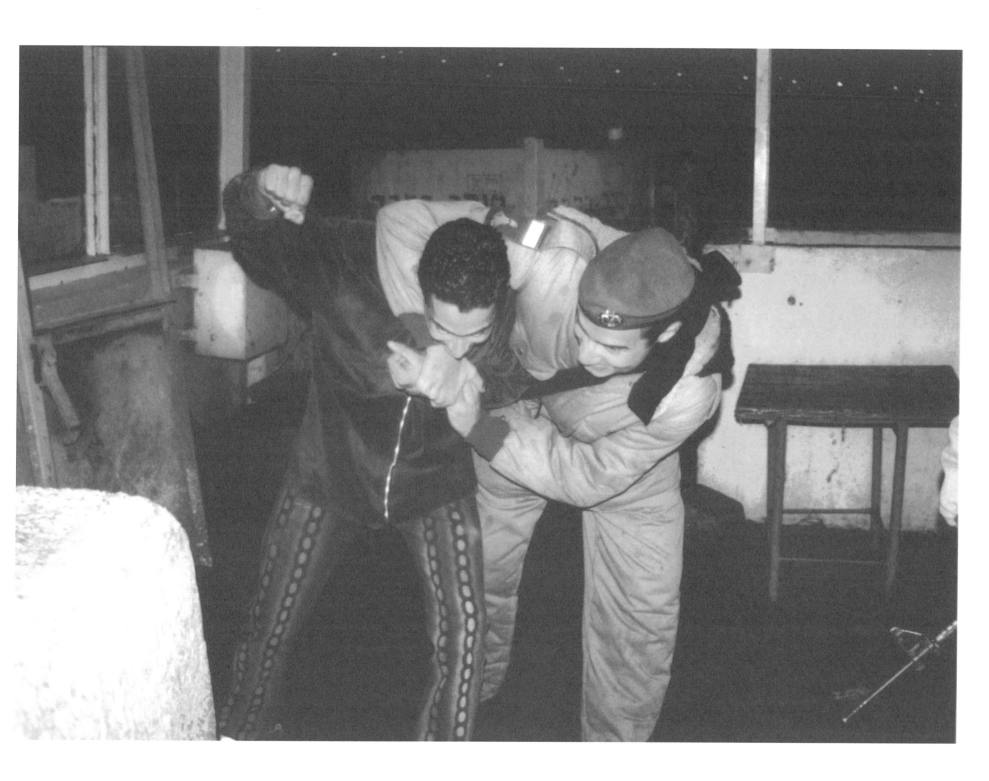

41

RAMALLAH, PALESTINE

Moving from Israel, the photos will now take you through Ramallah, Palestine. Through the streets, civilians take place in protests, and children play.

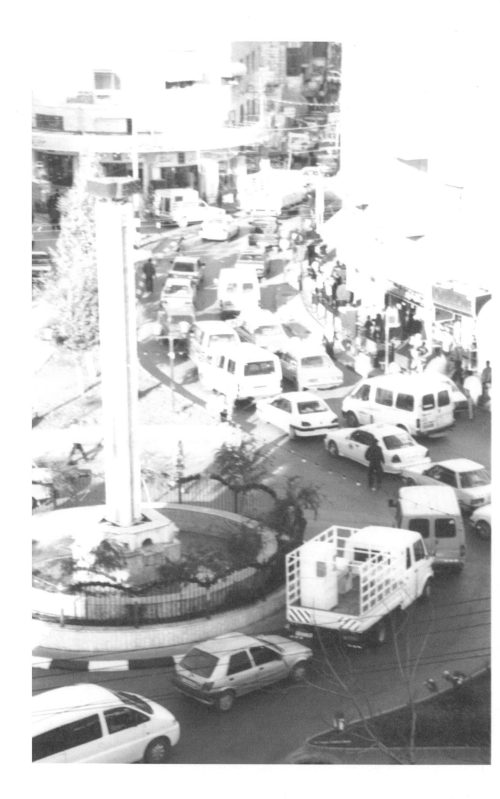

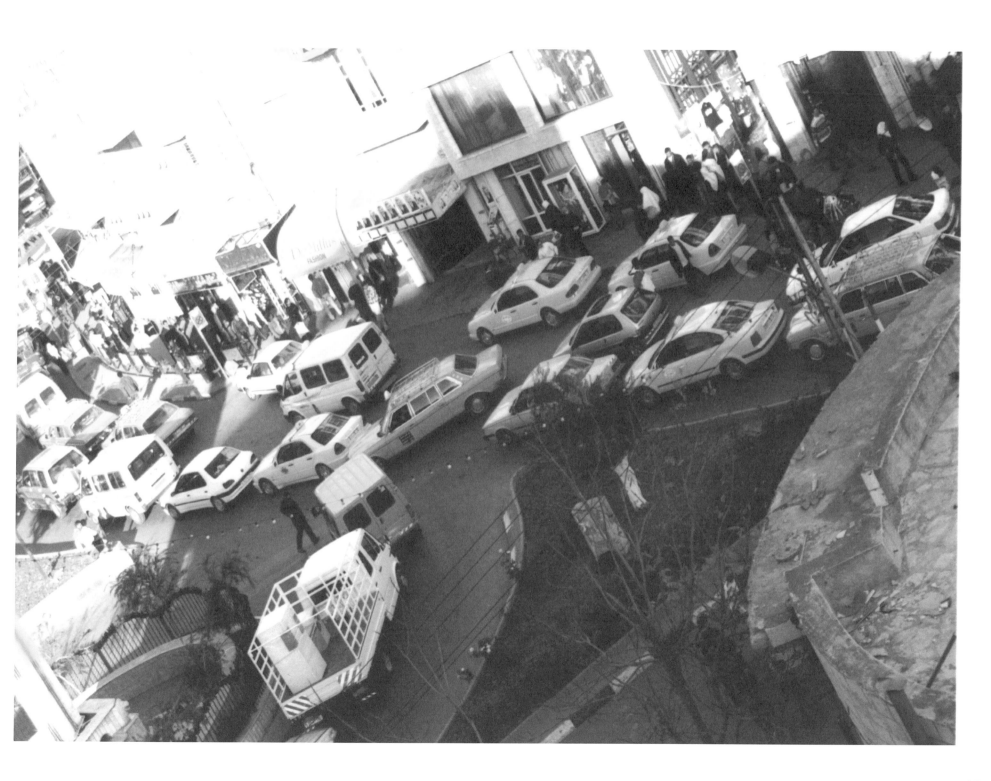

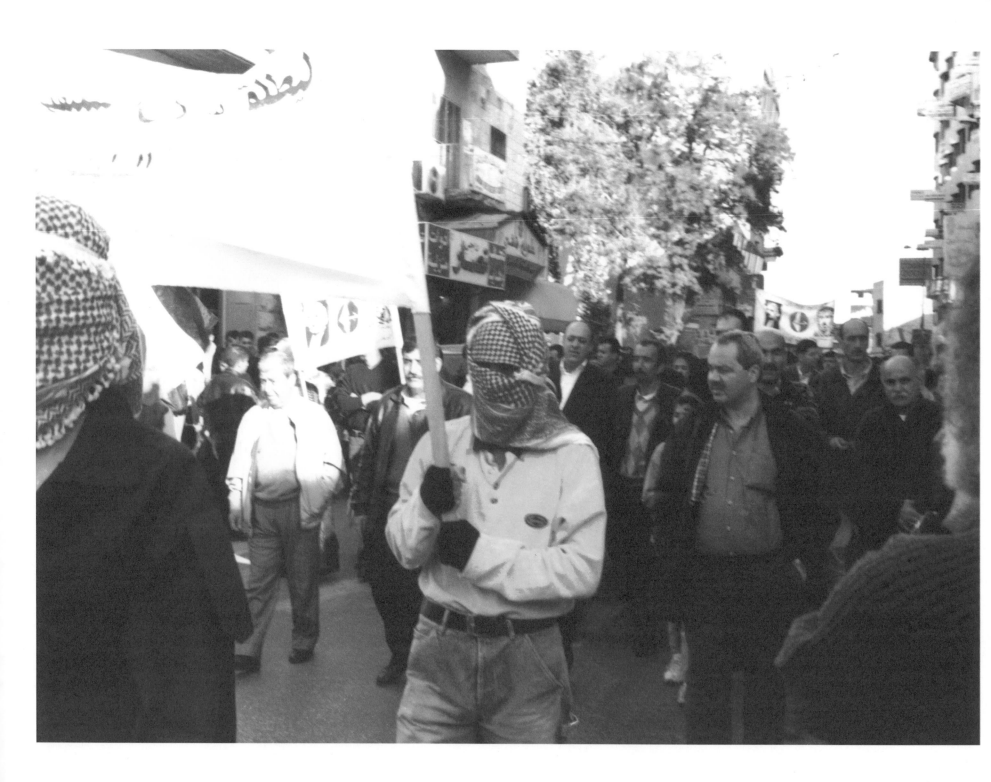

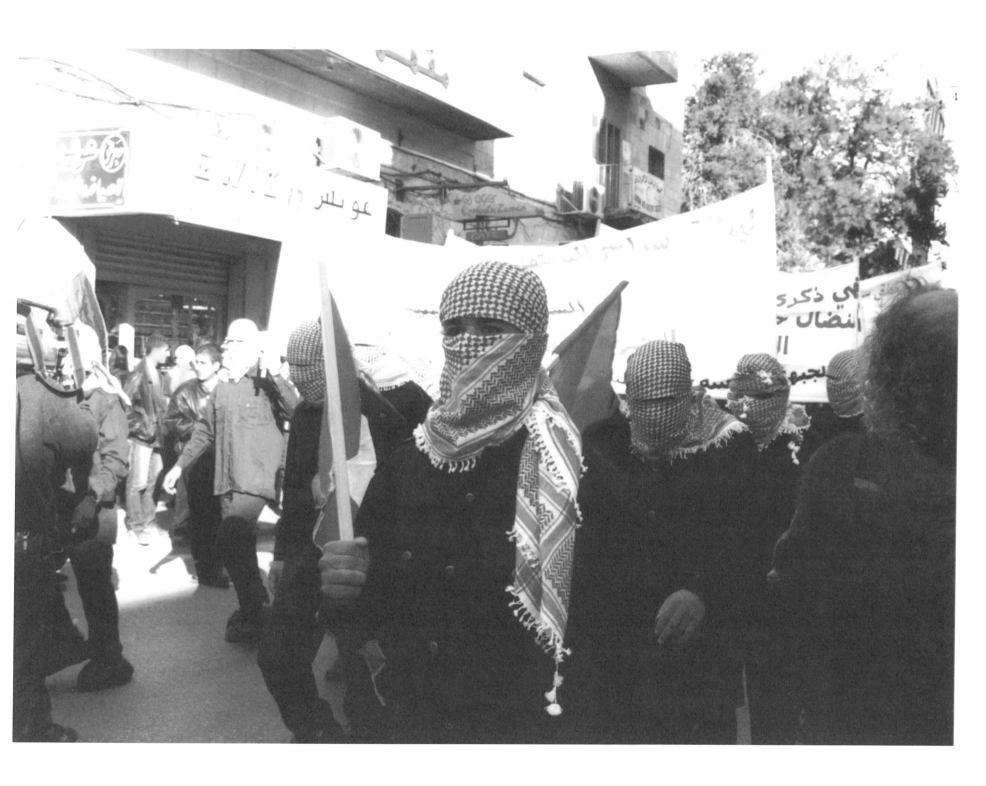

45

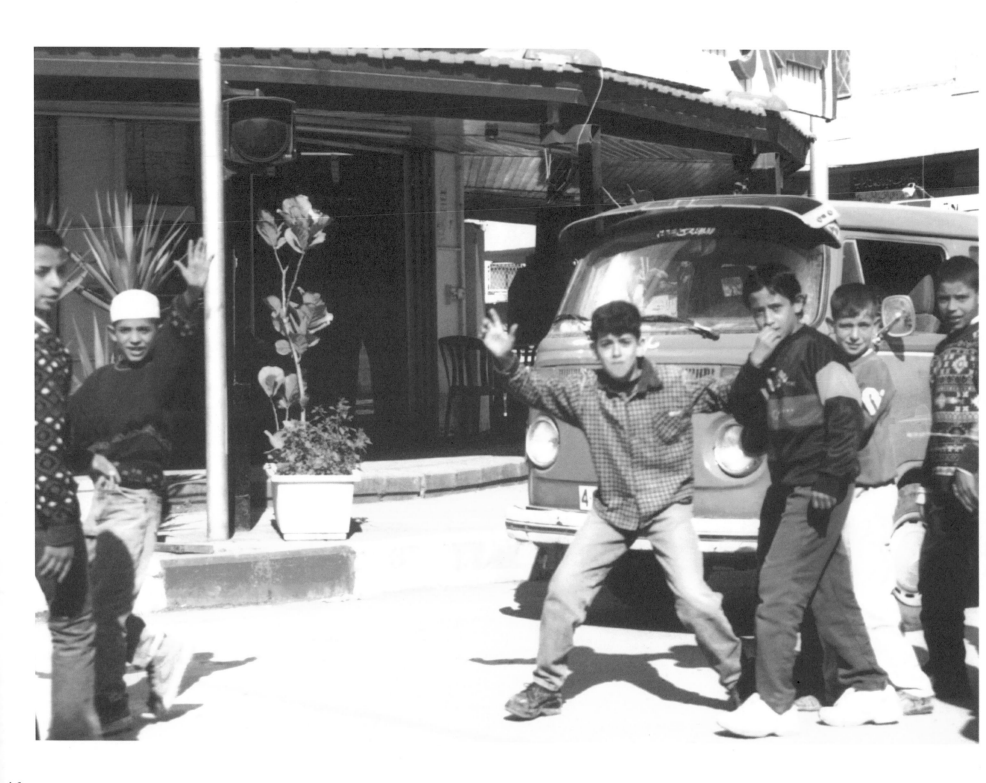

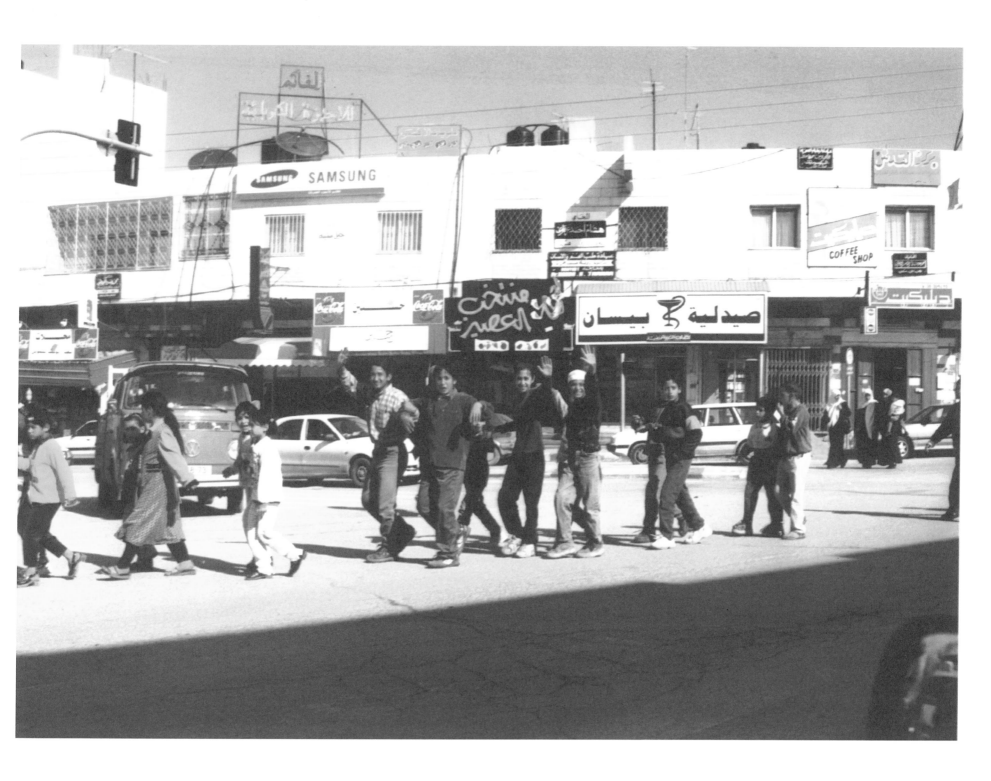

WEST BANK, PALESTINE

West Bank, Palestine is the next stop. Through the beautiful lands, family gathers, and love is shared.

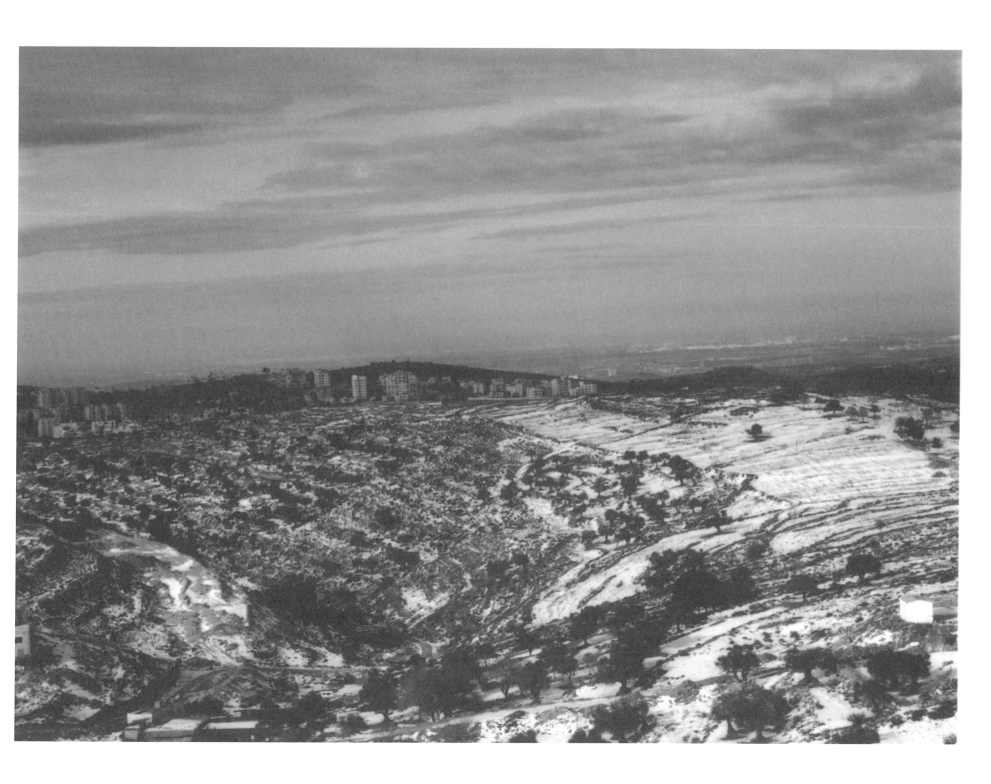

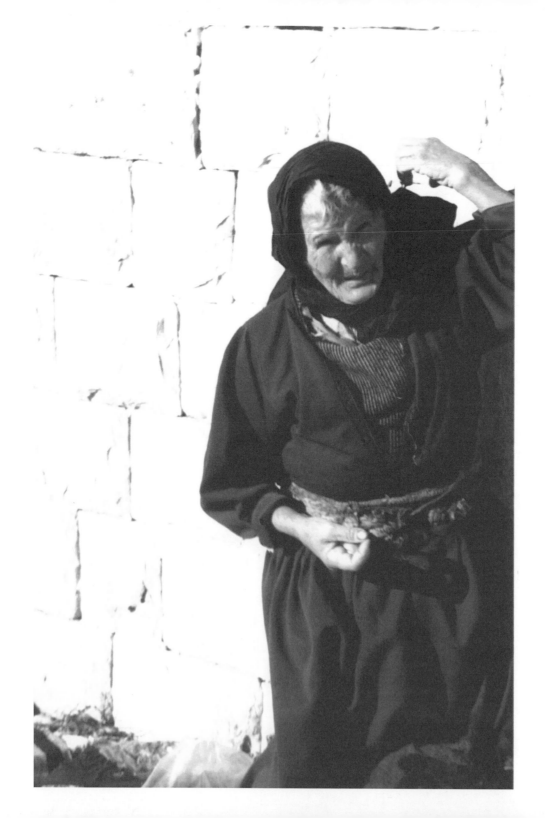

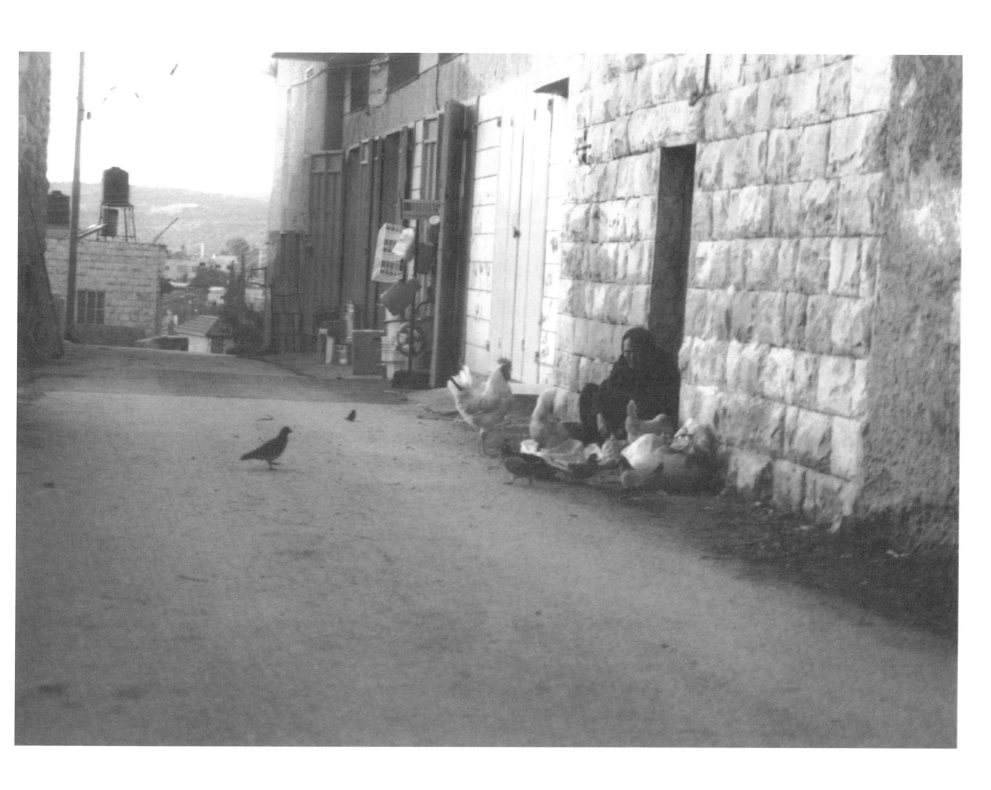

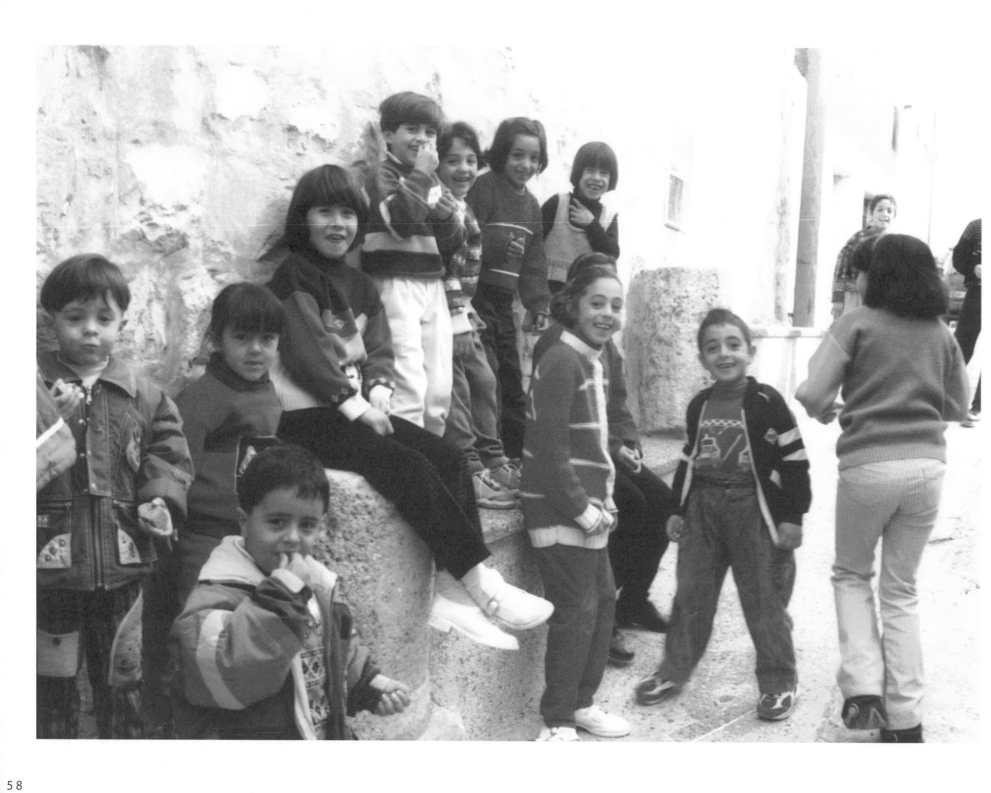

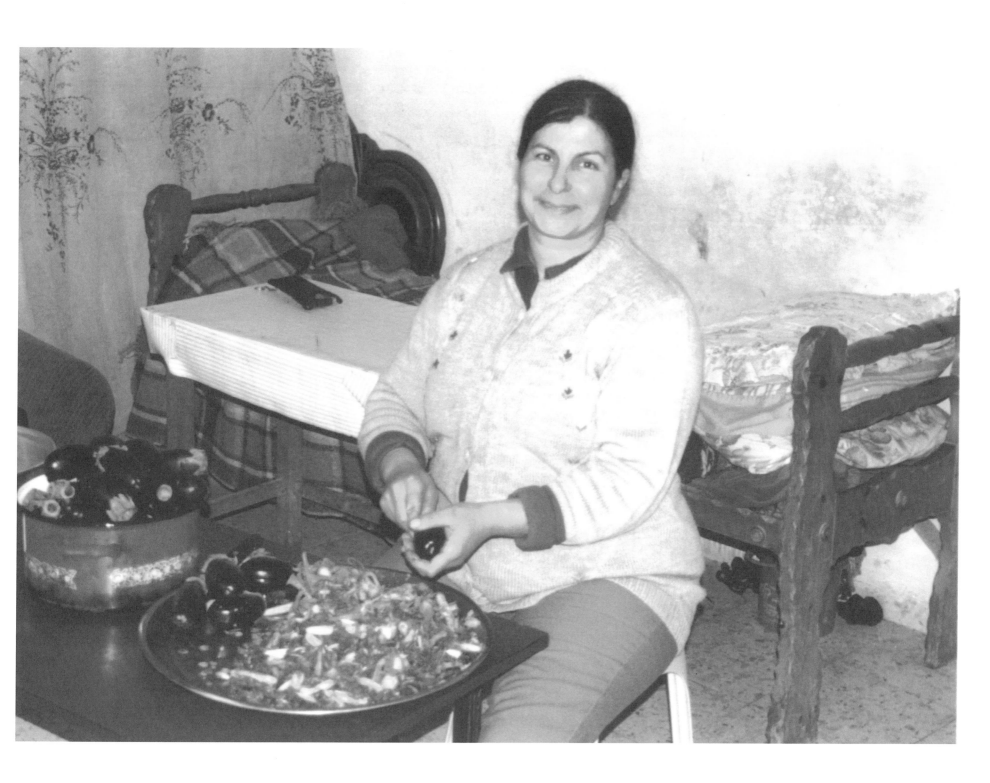

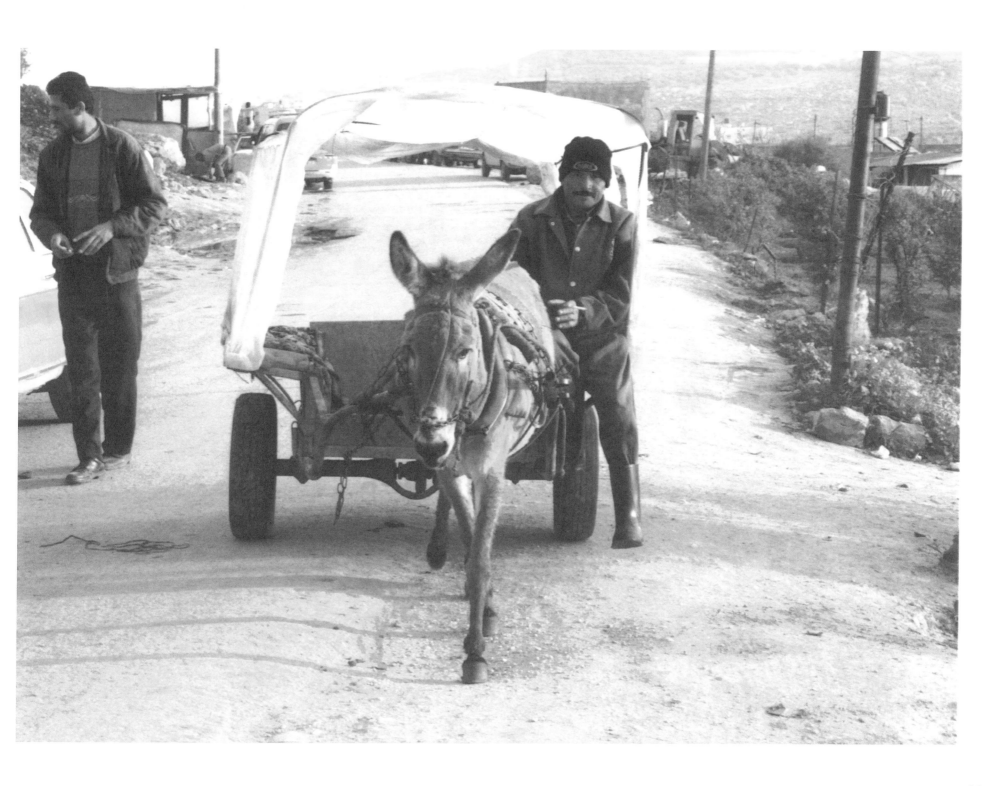

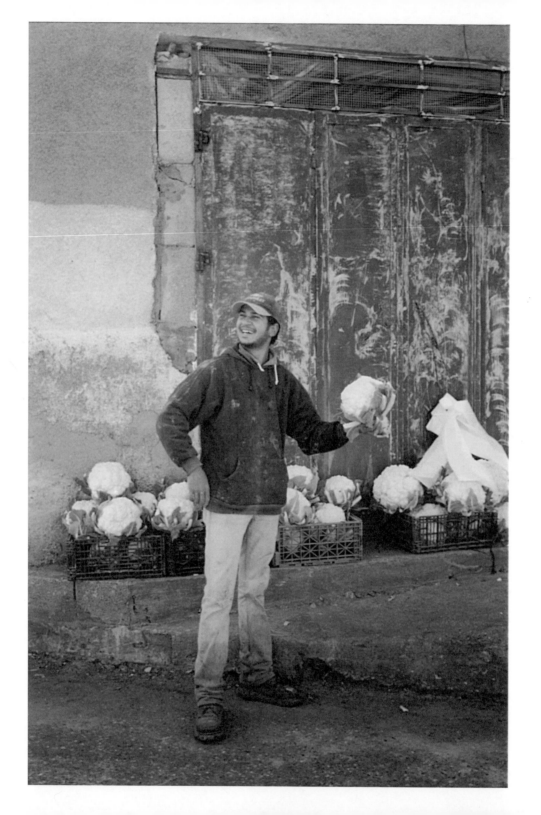

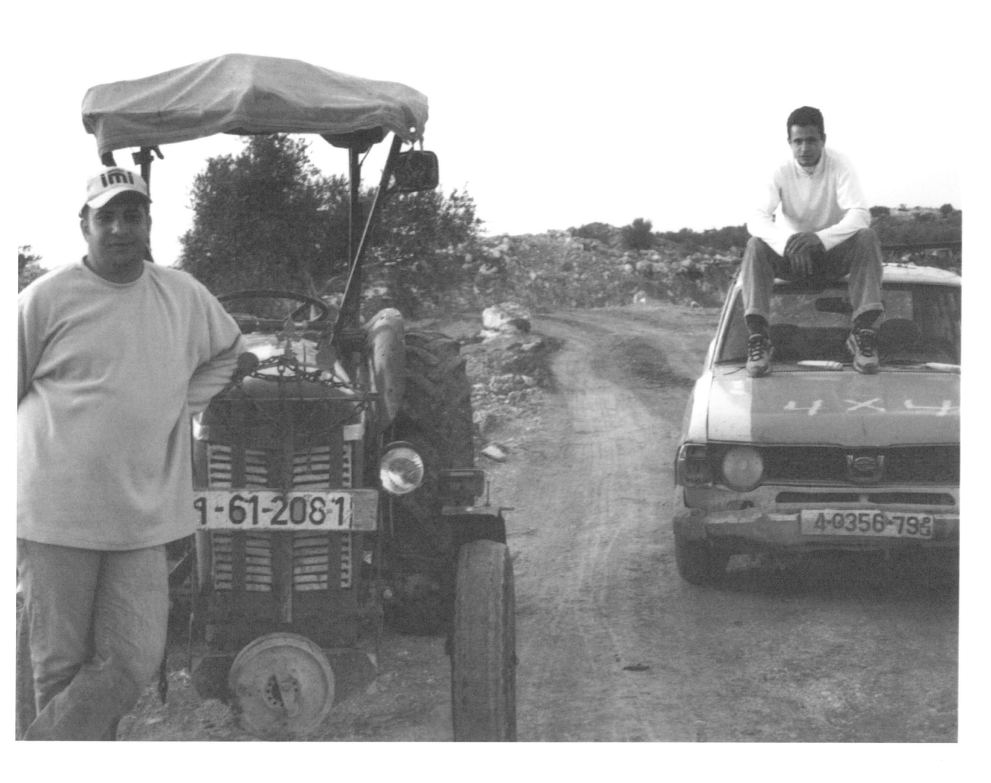

63

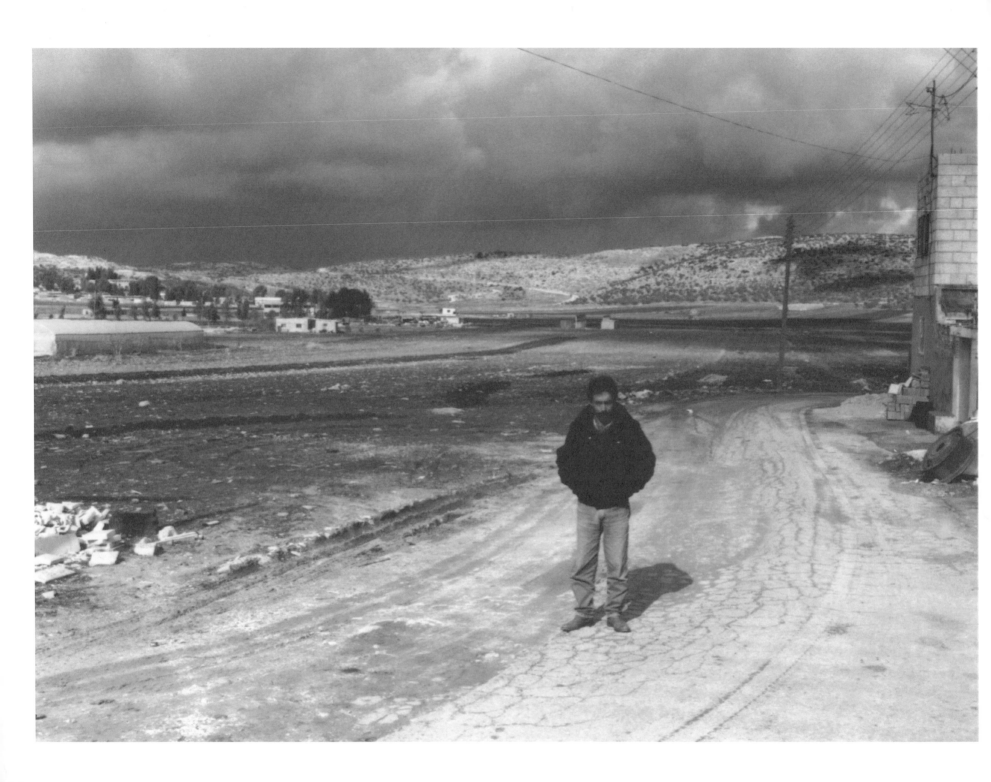

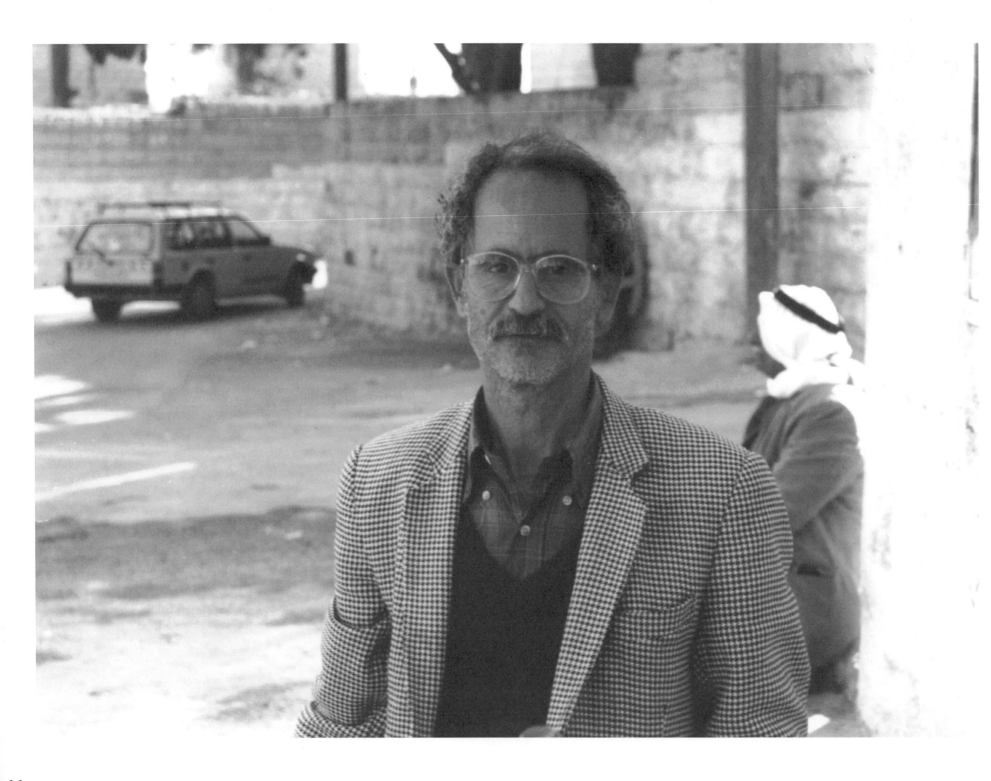

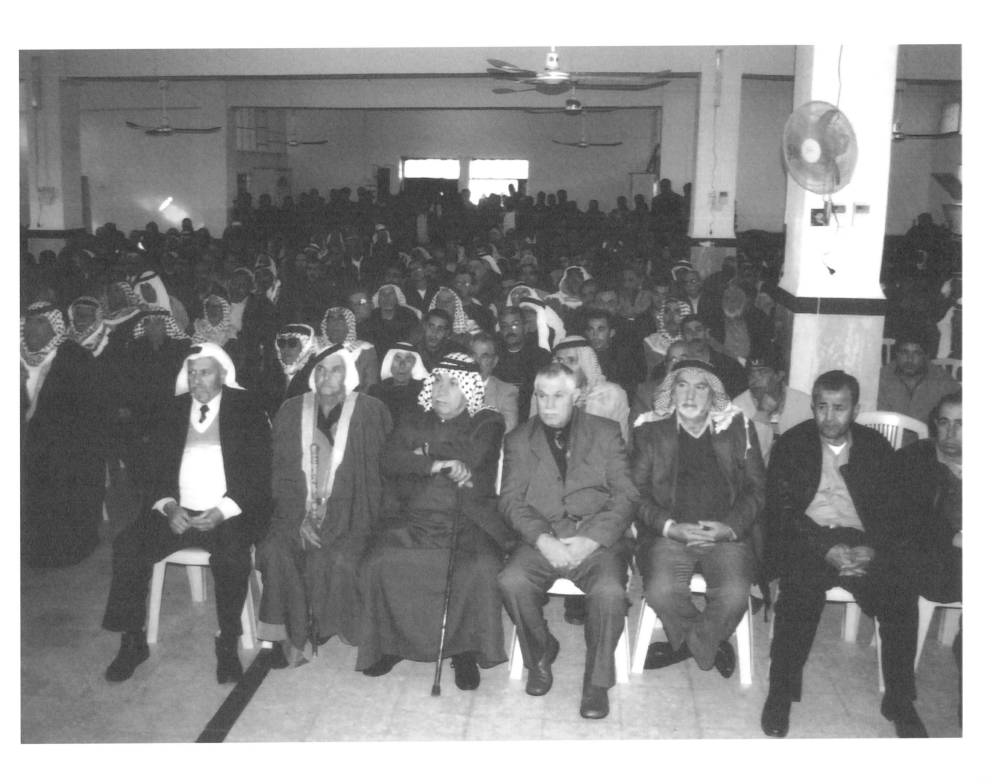

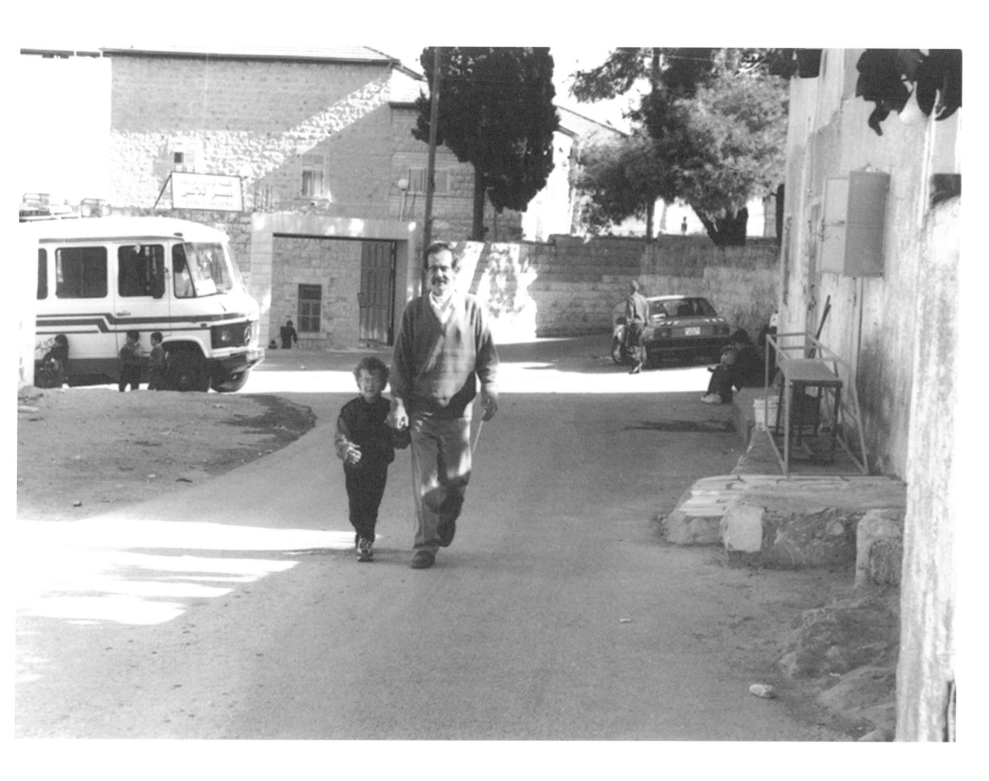

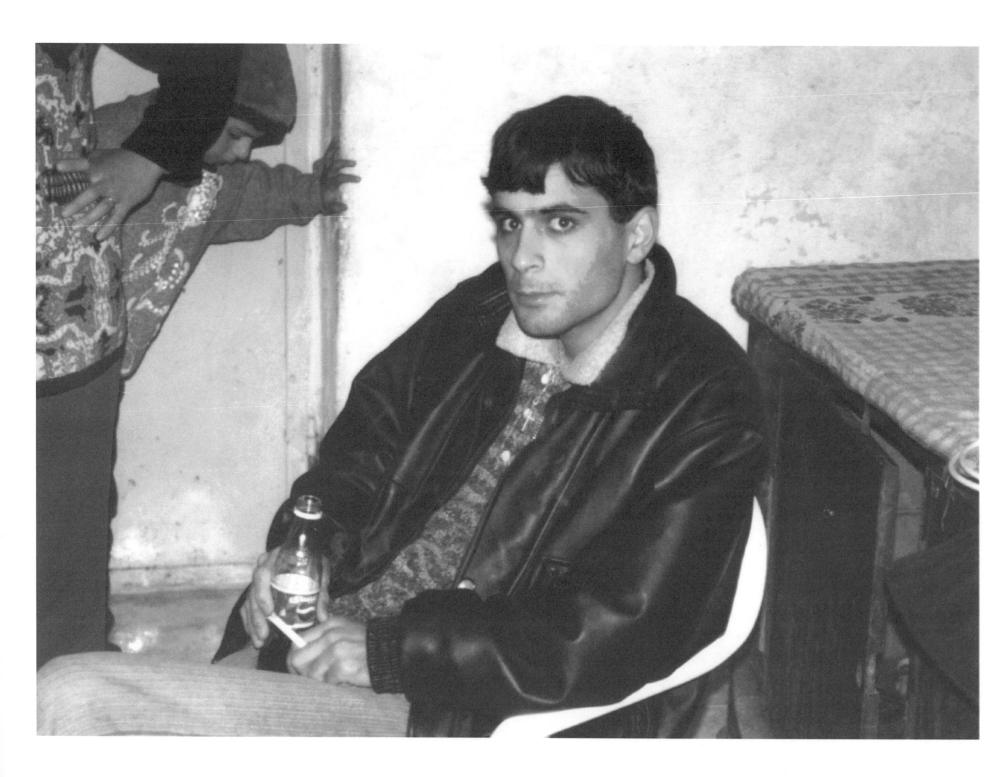

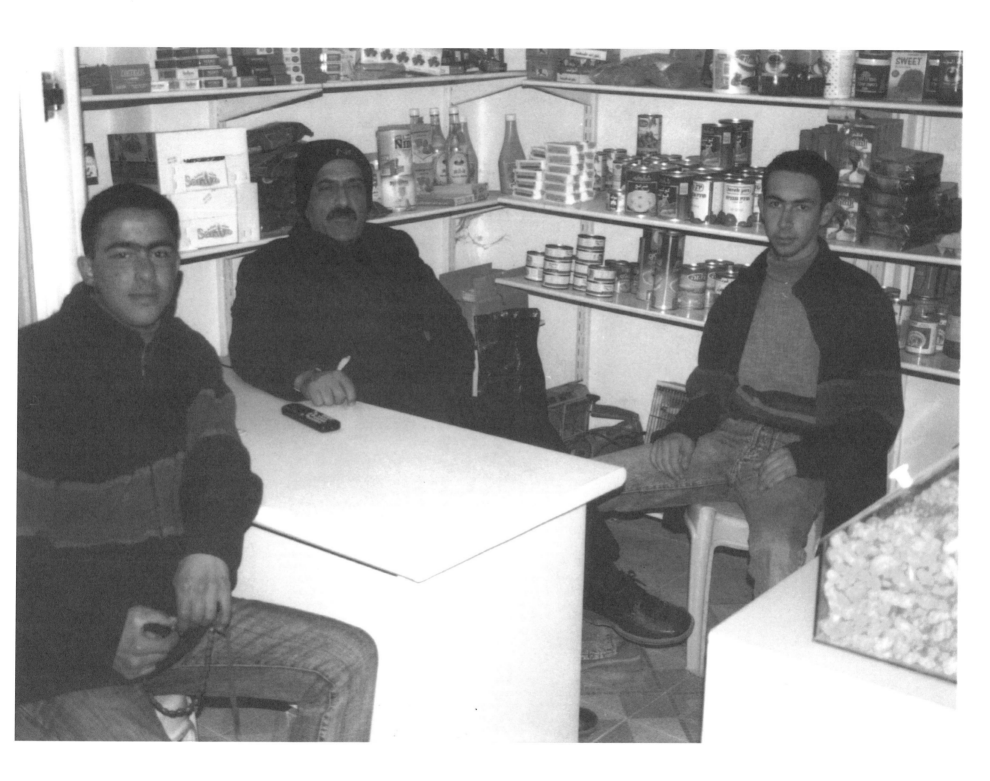

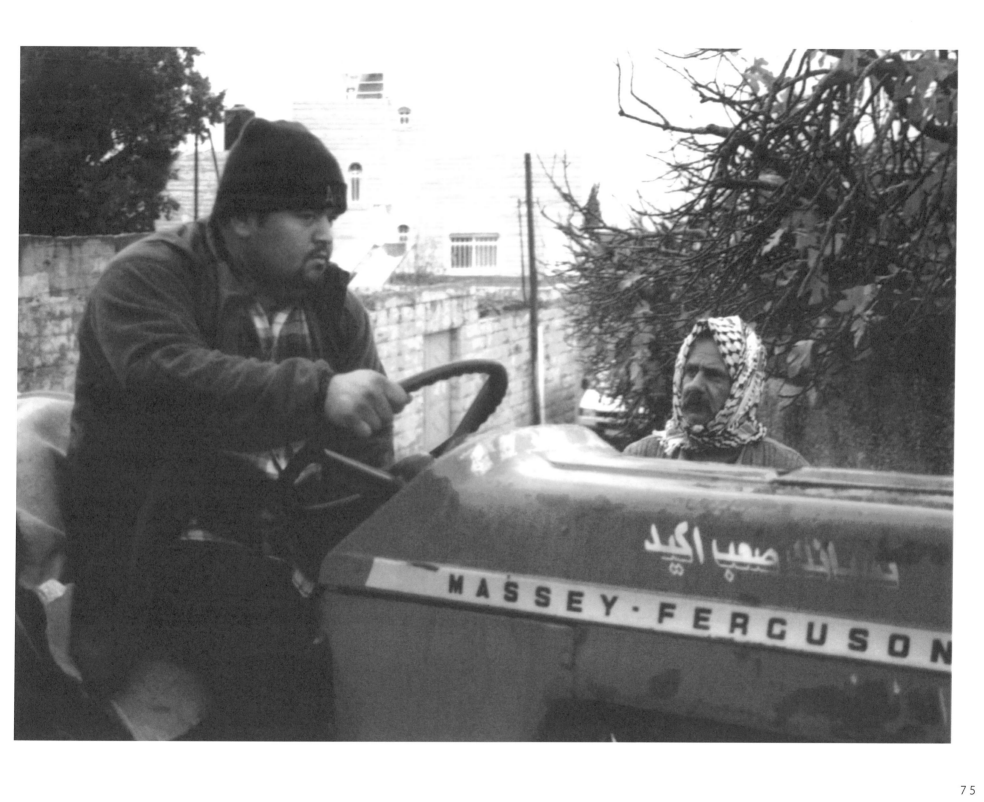

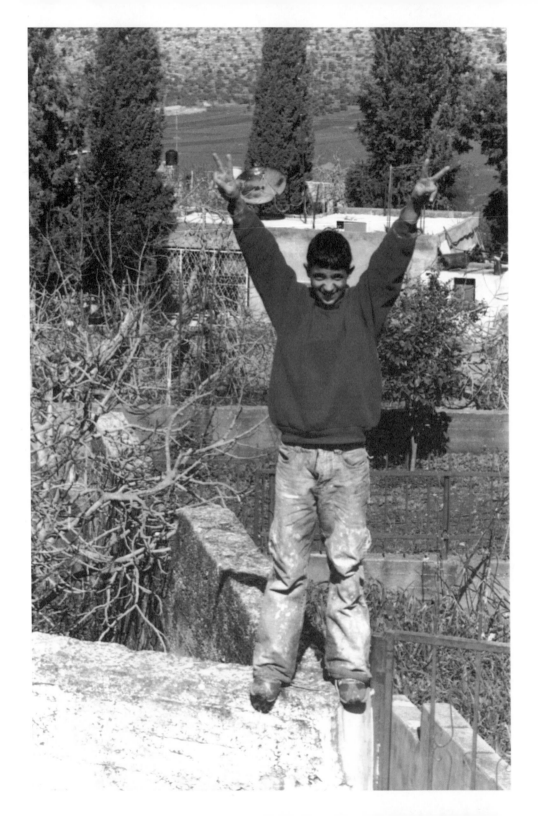

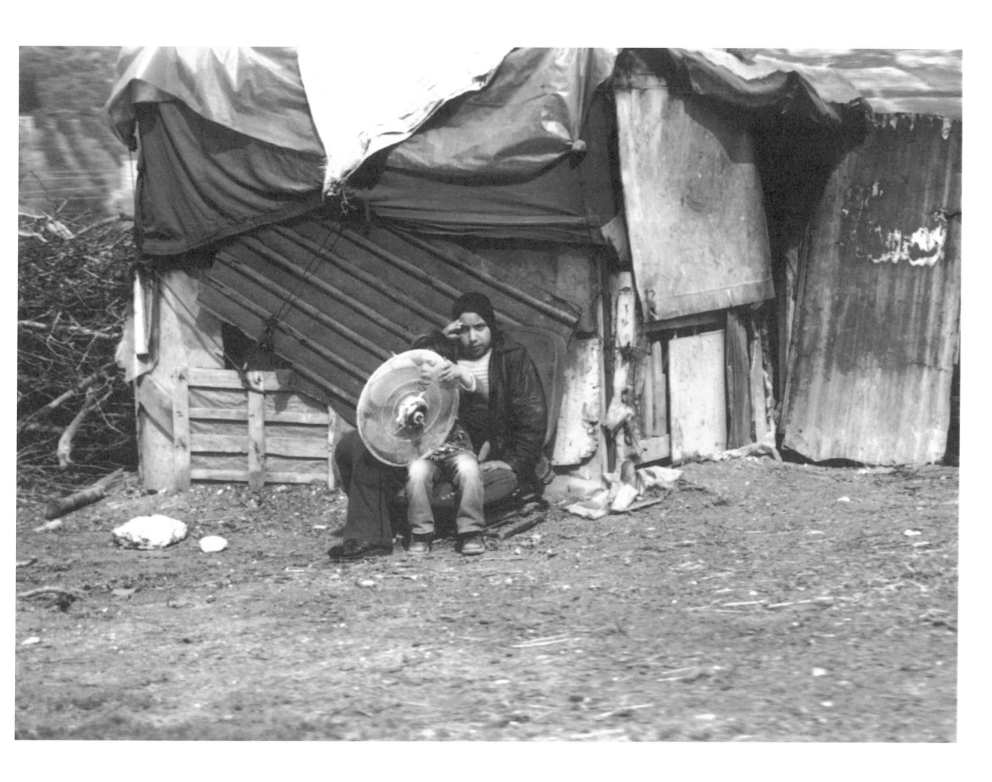

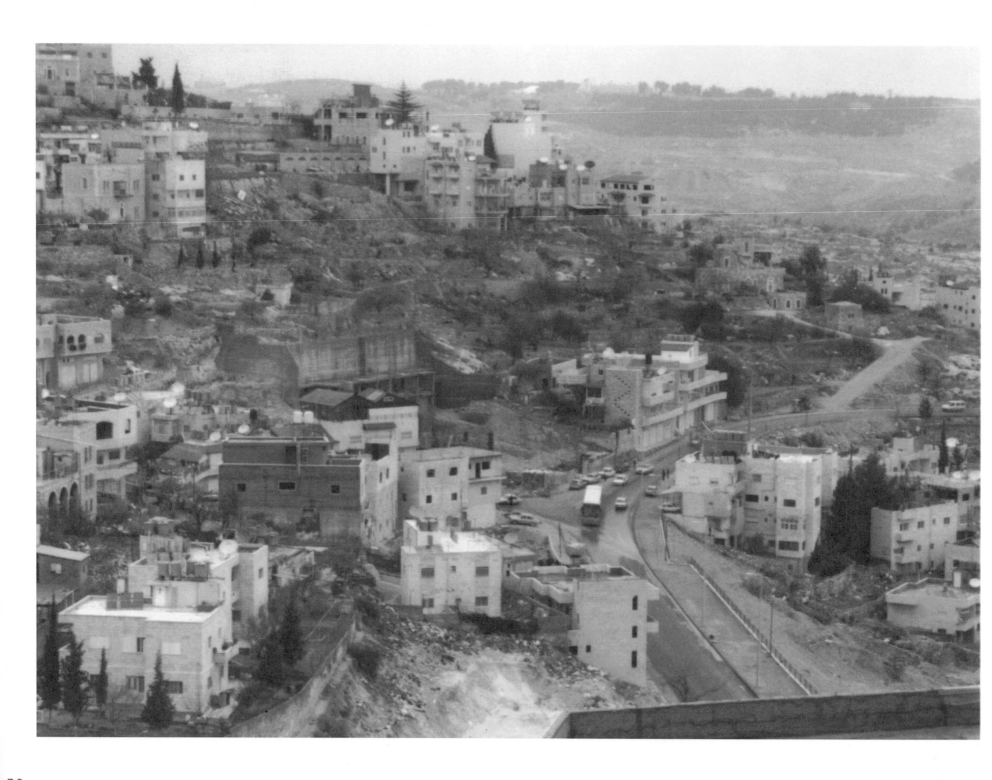

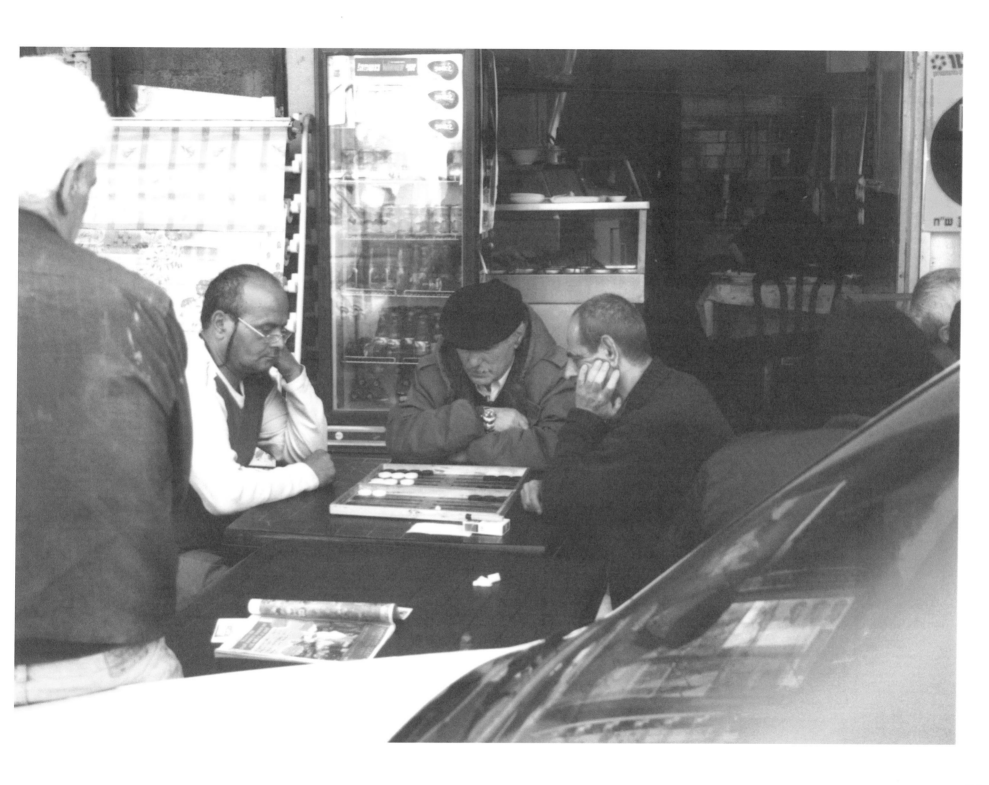

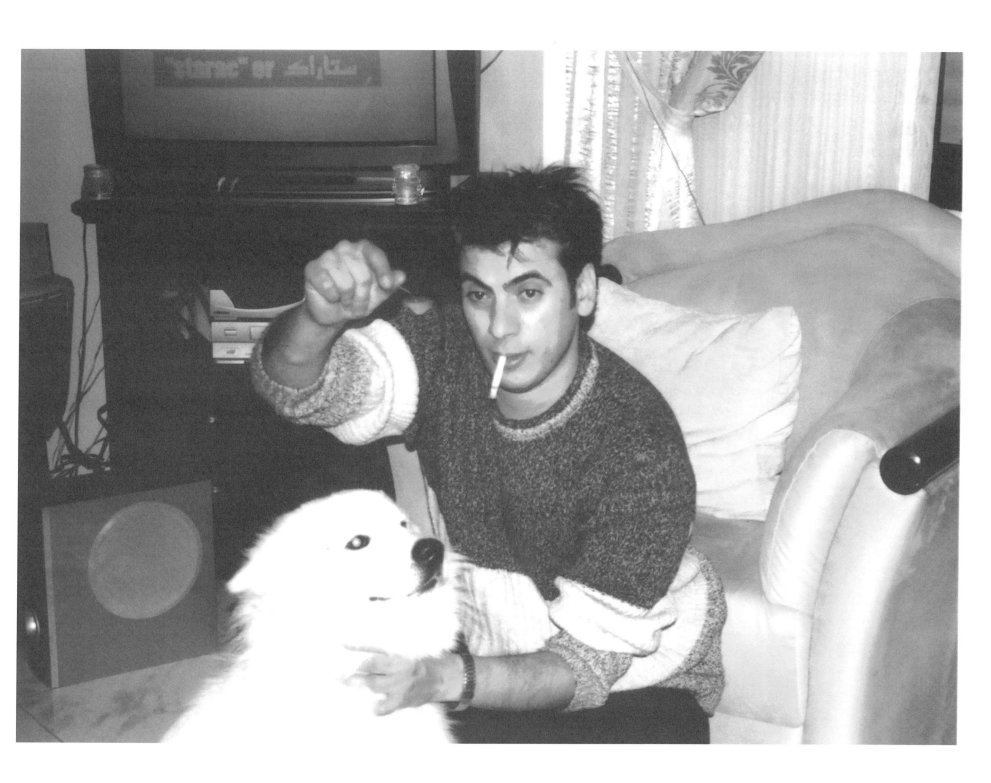

83

Tourists visiting Zababdeh, West Bank experiencing the region and it's historical significance.

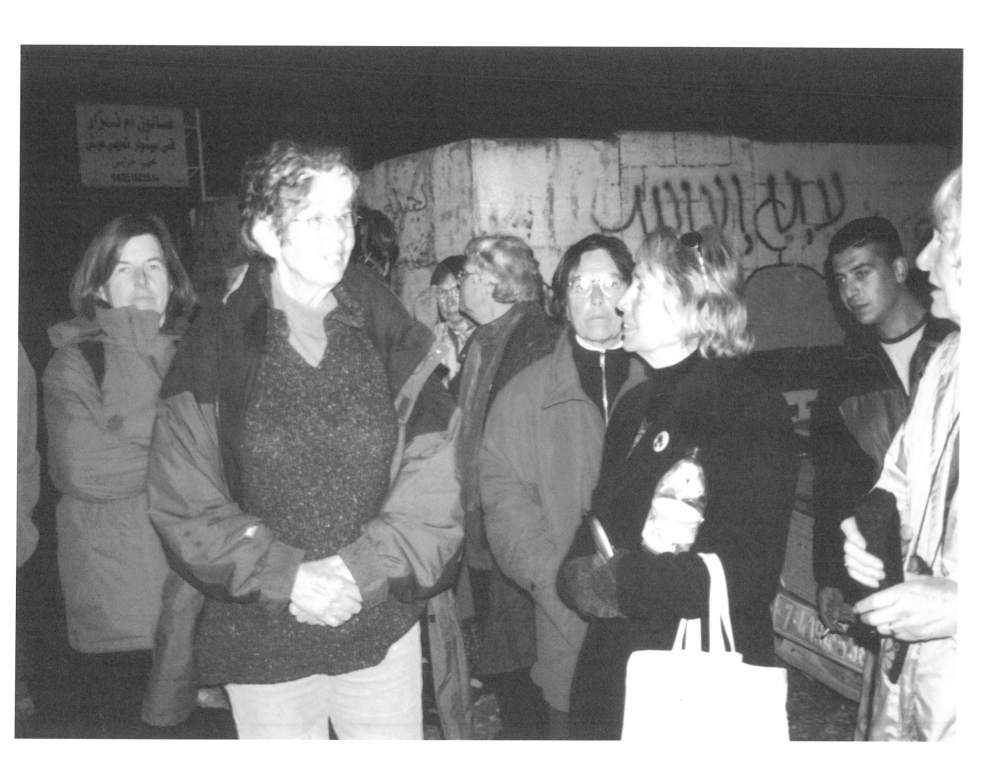

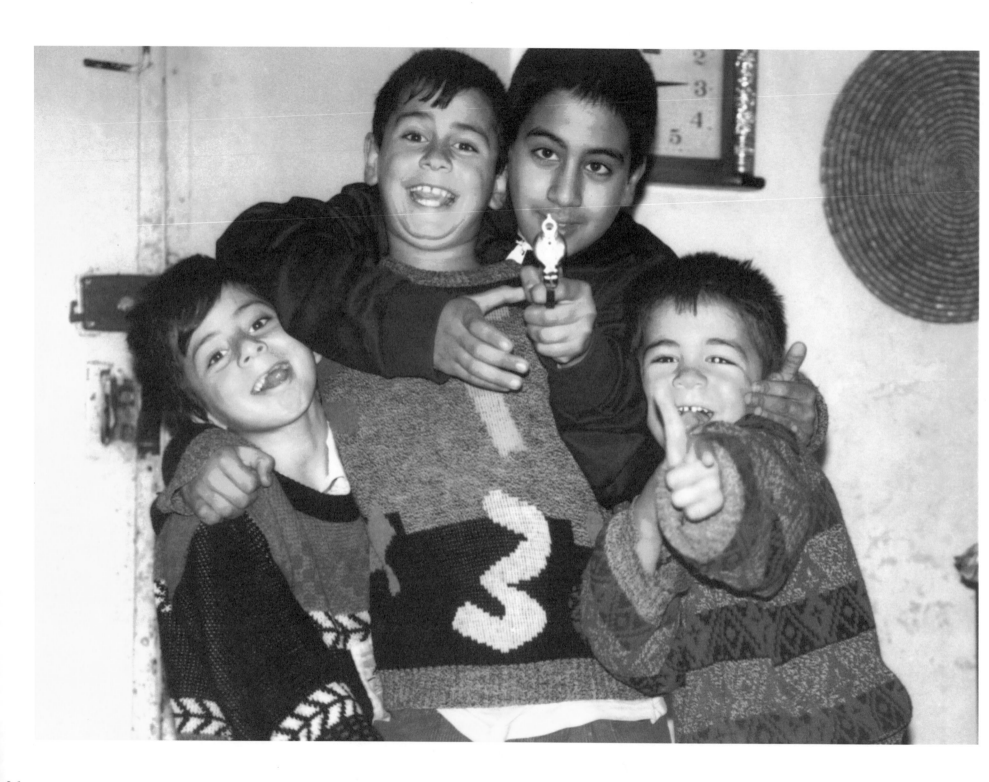

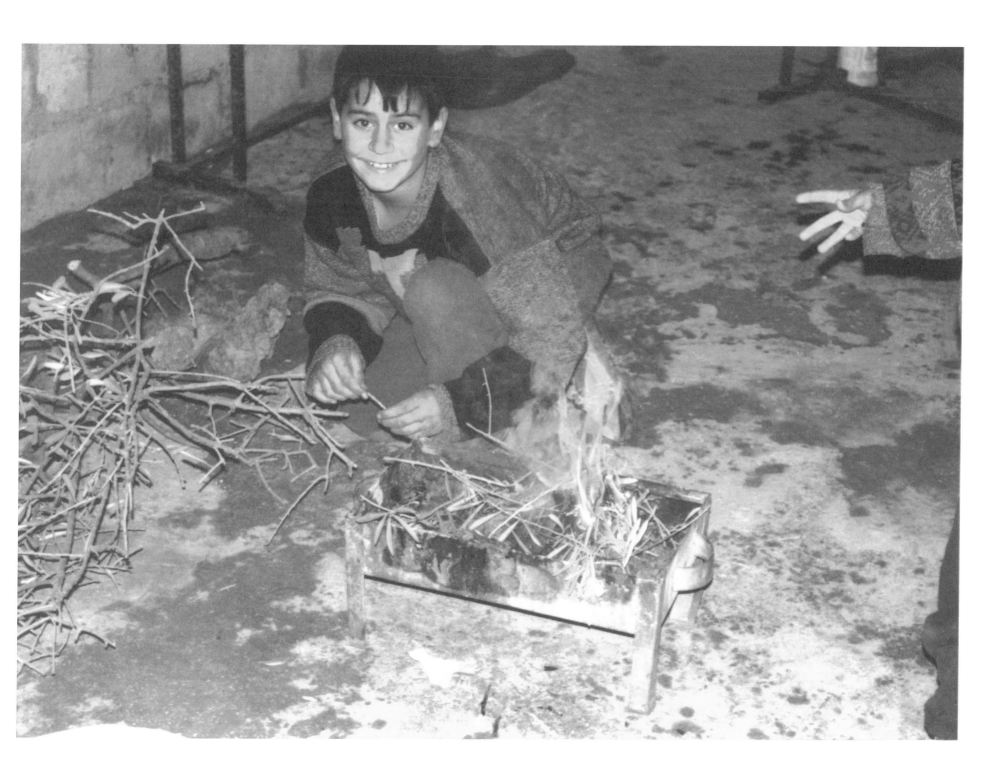

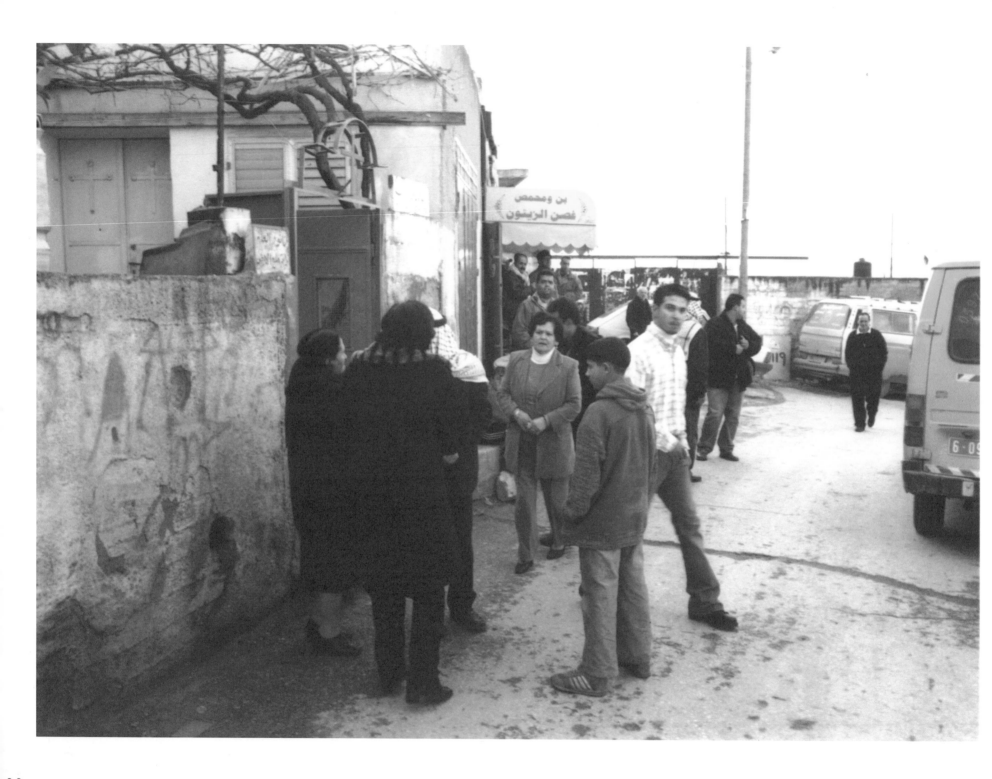

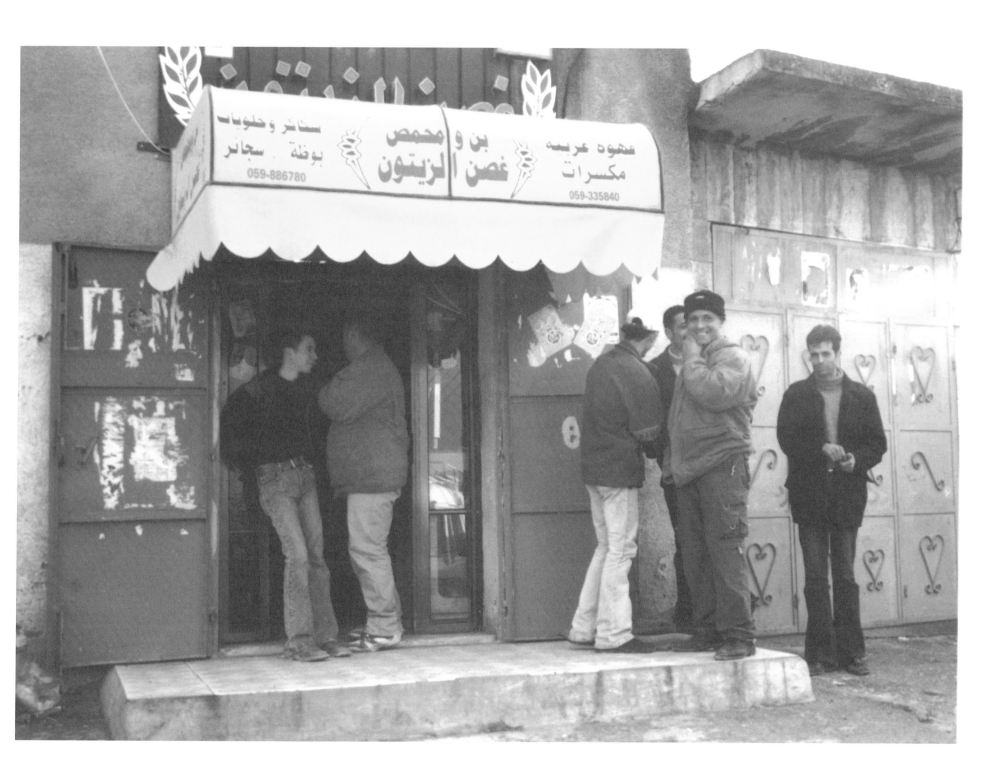

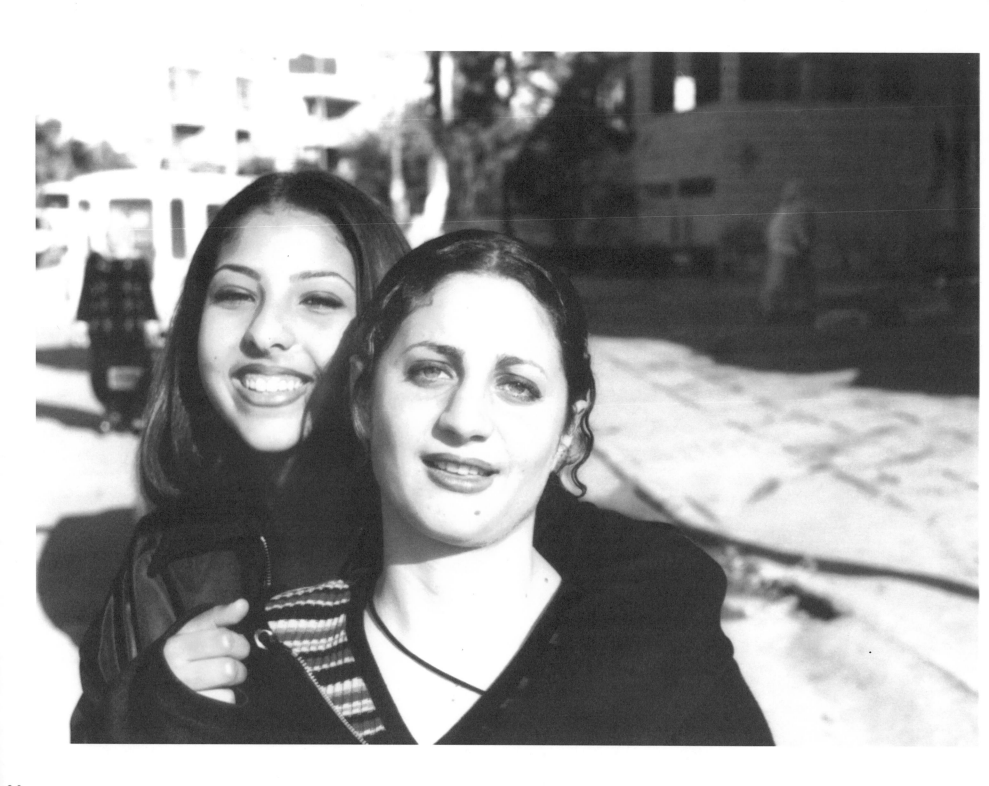

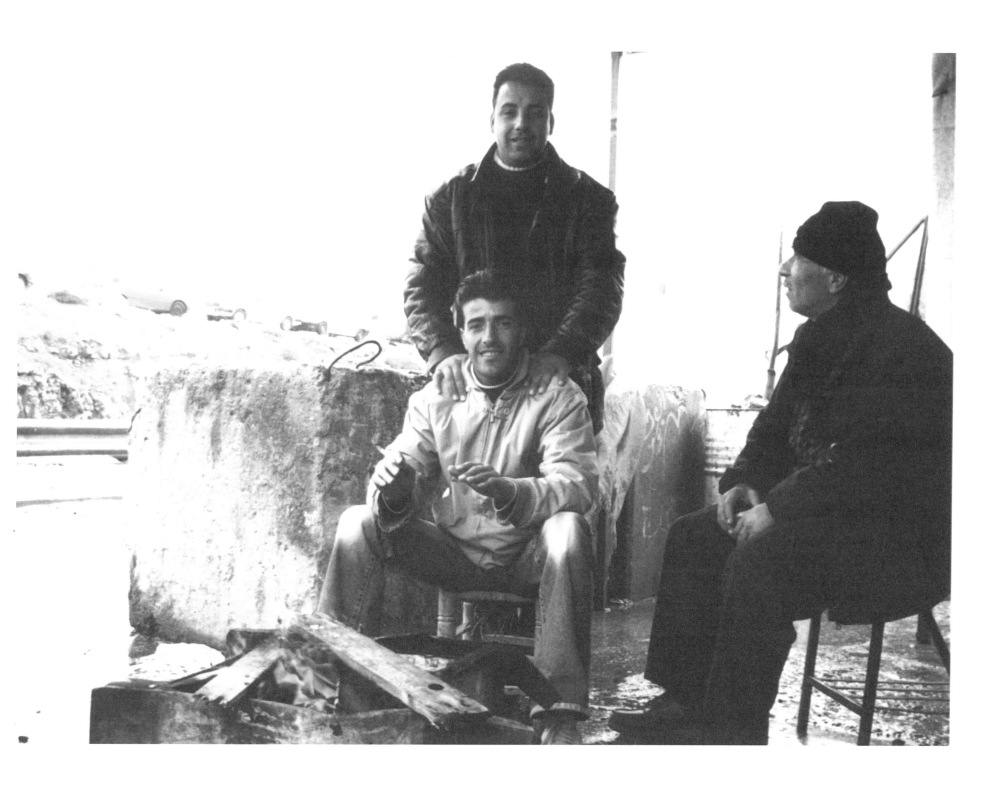

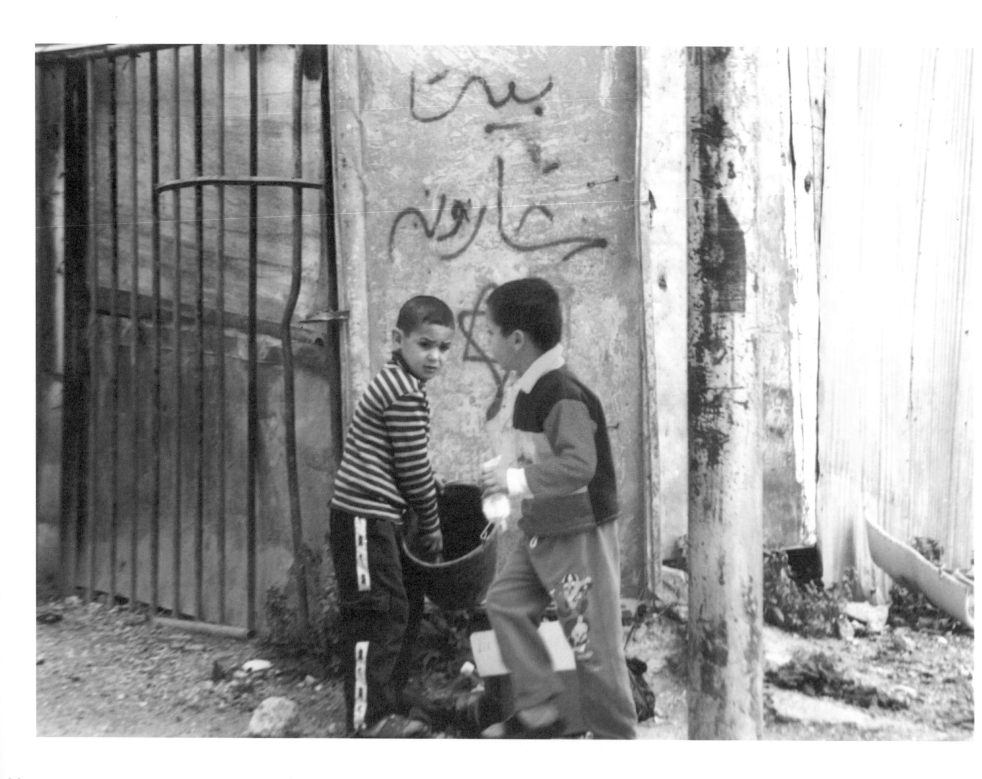

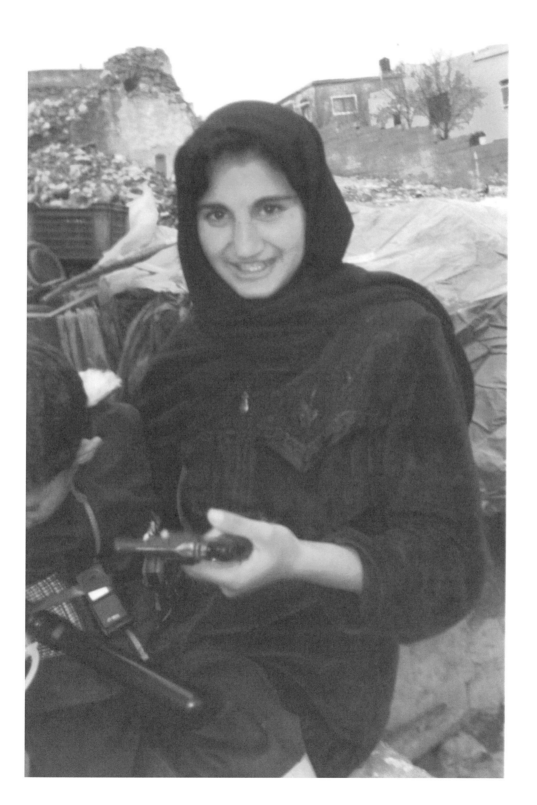

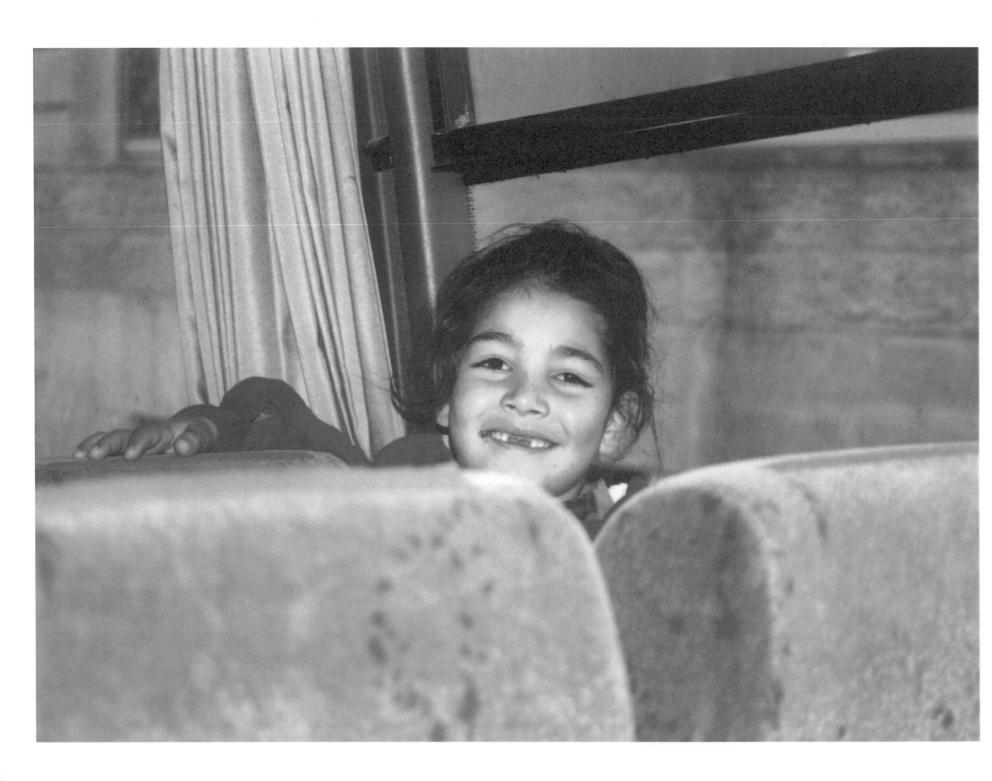

A tourist wearing a "Refuse" t-shirt at an Israeli checkpoint.

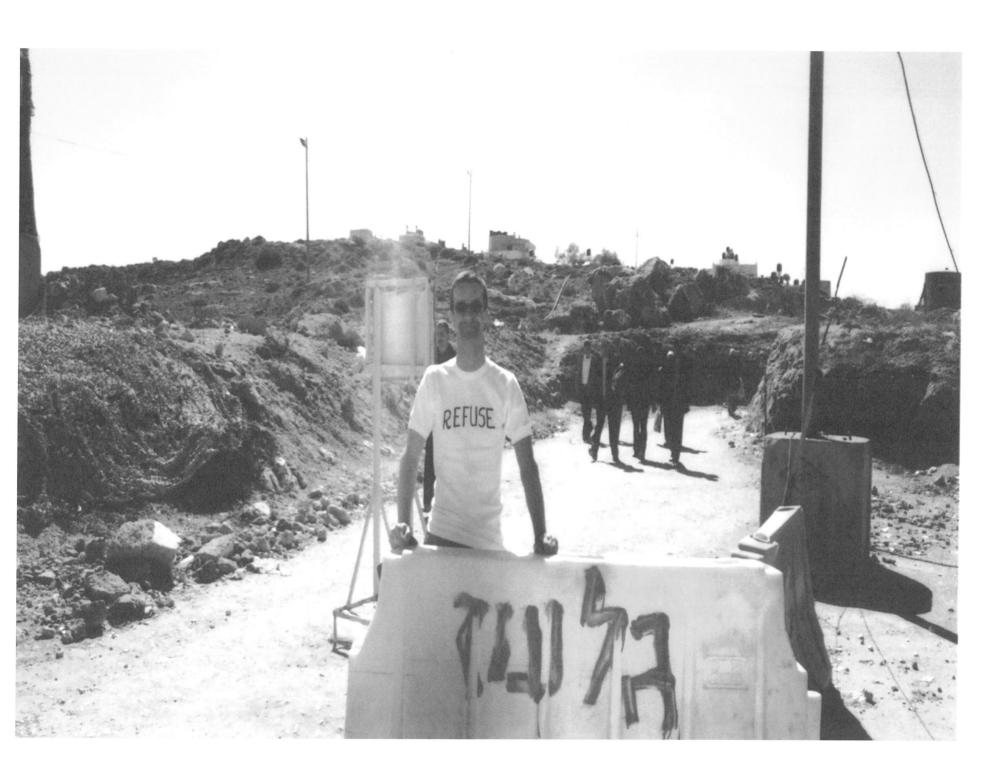

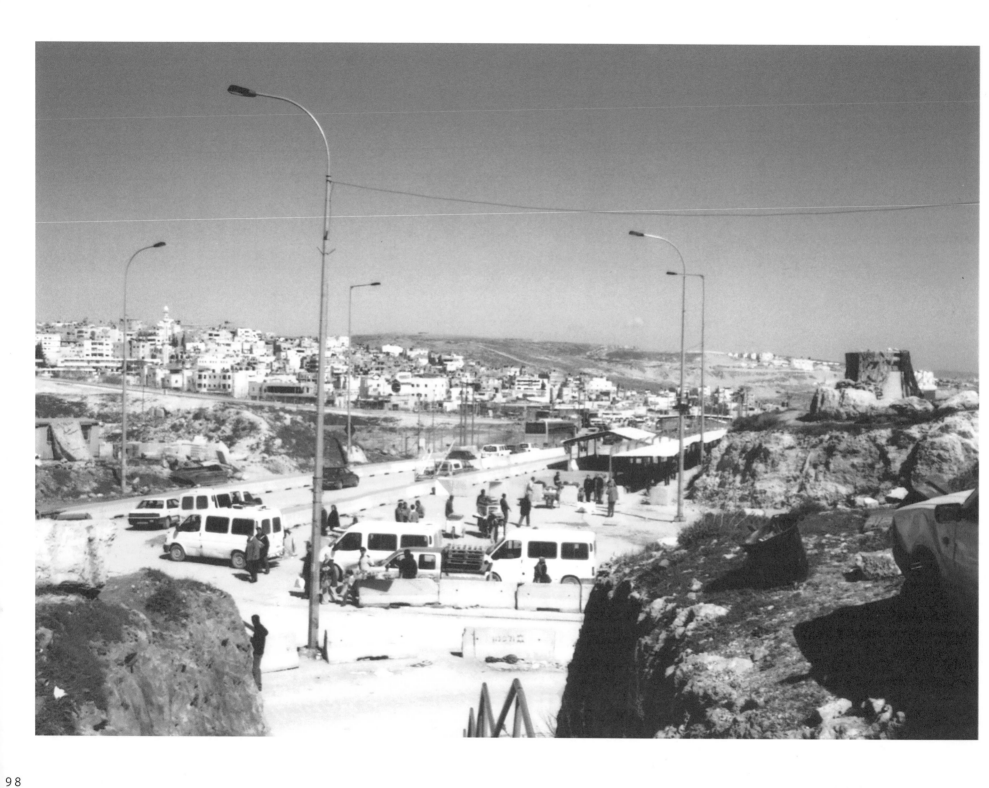

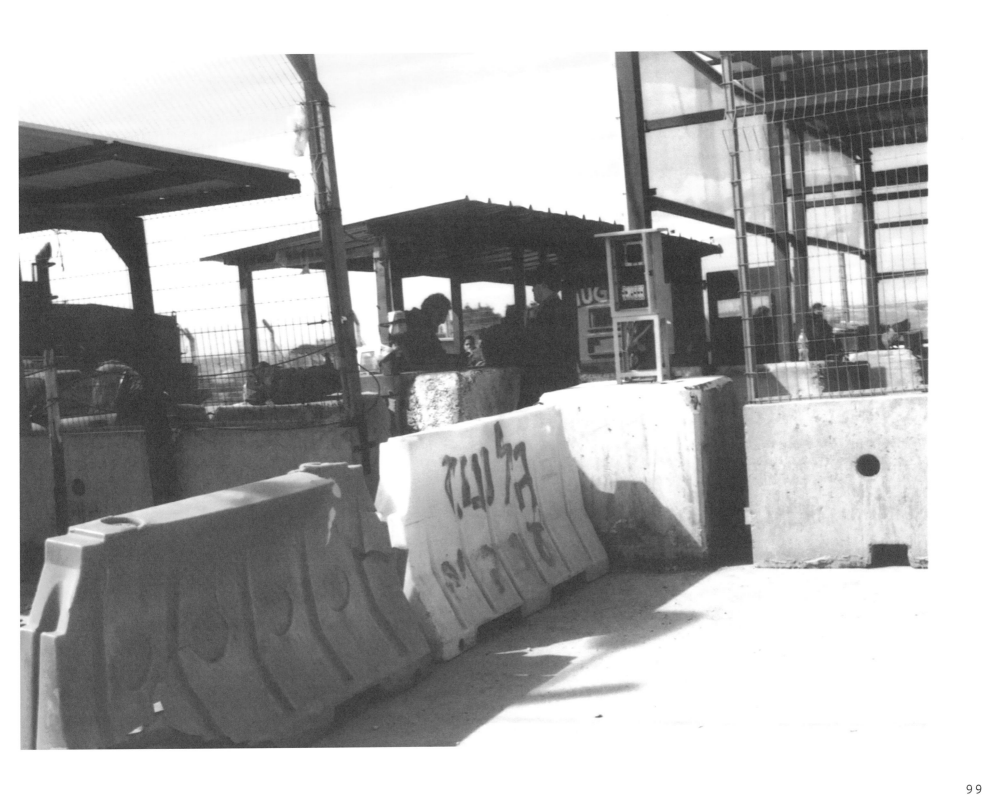

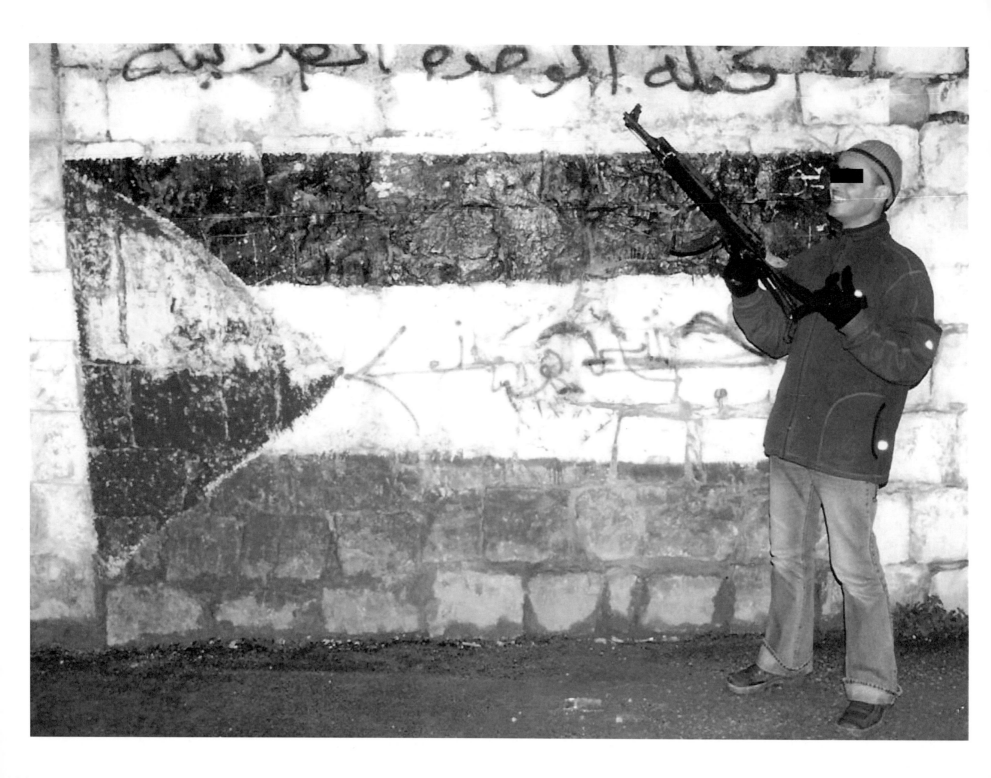

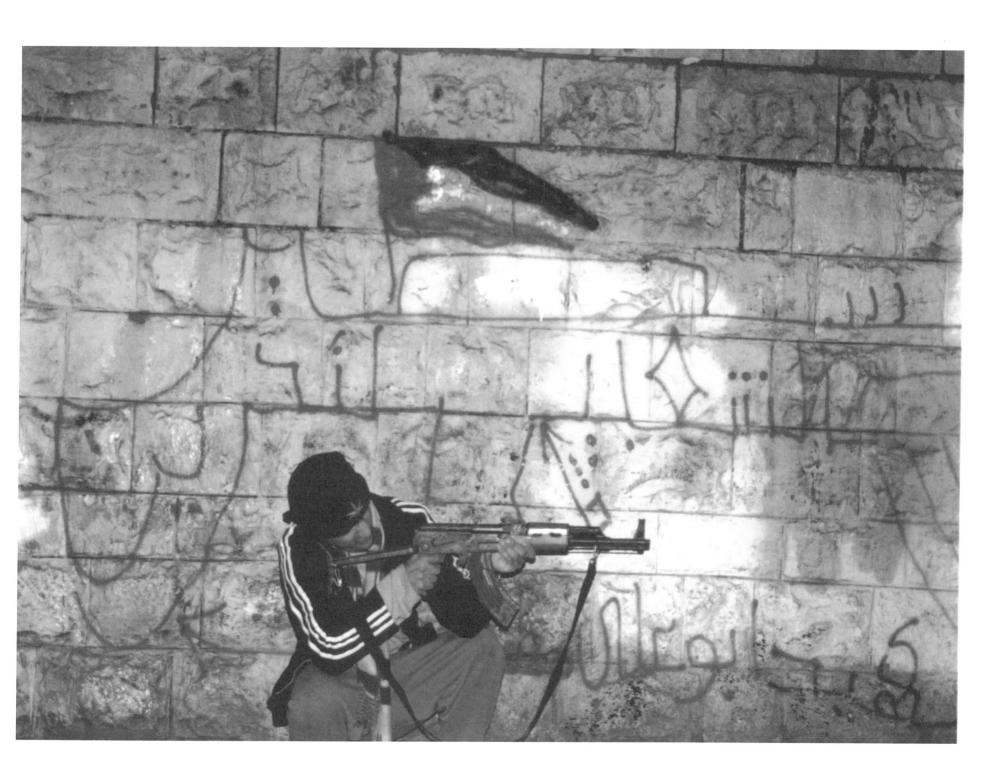

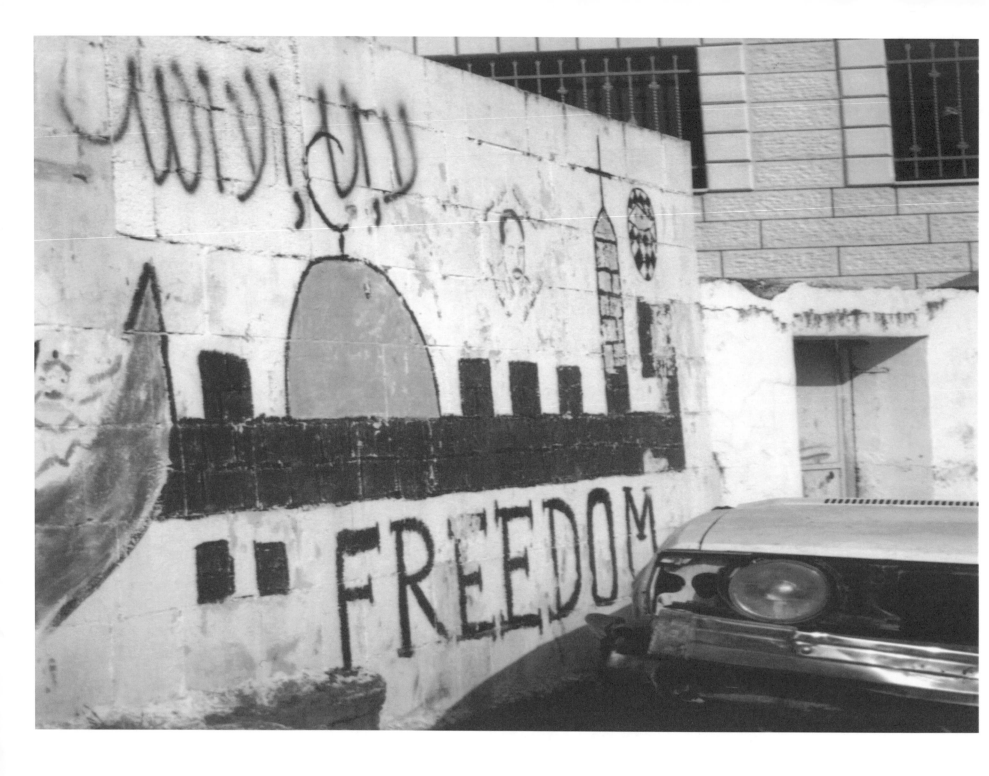

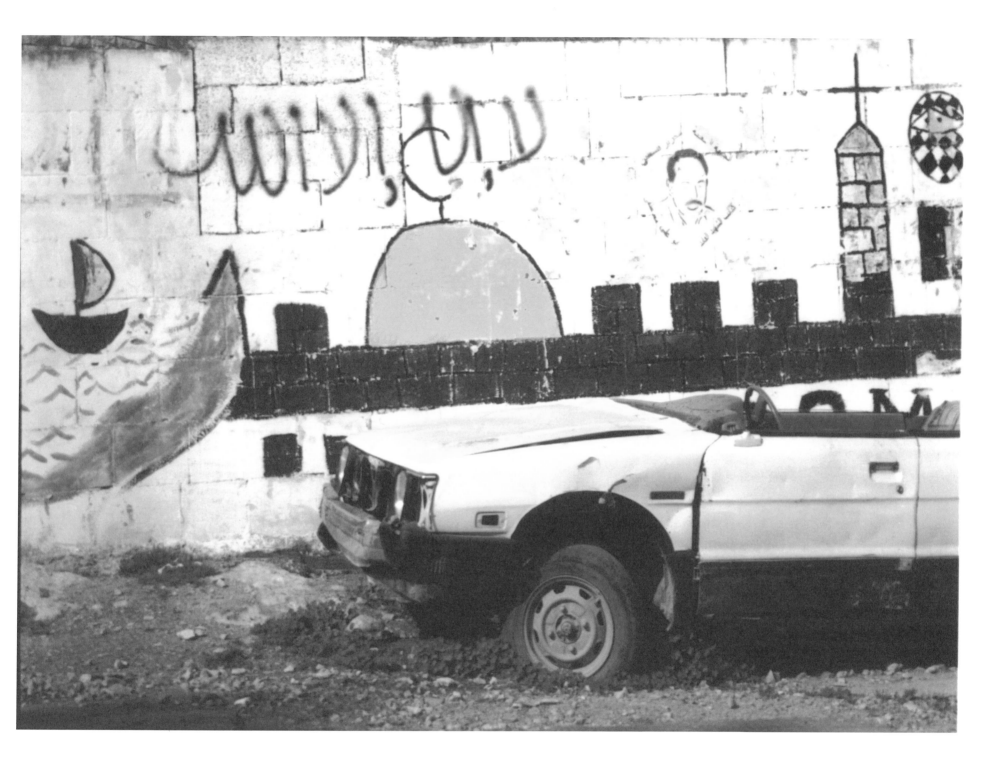

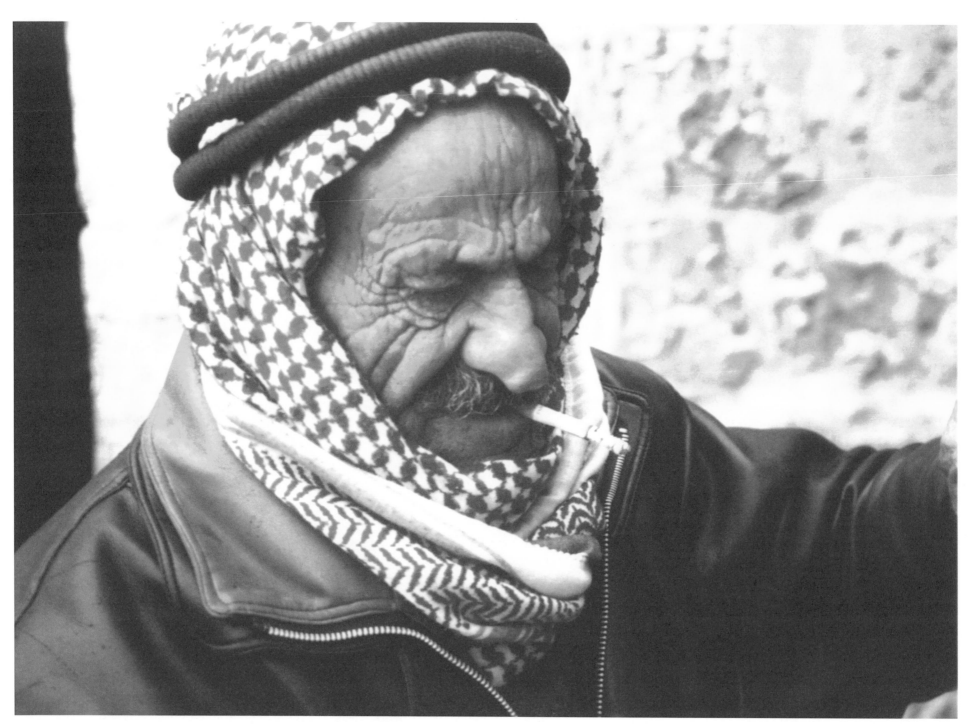

The Gatekeeper of the Mount of Olives Ancension Monastery in Jerusalem.

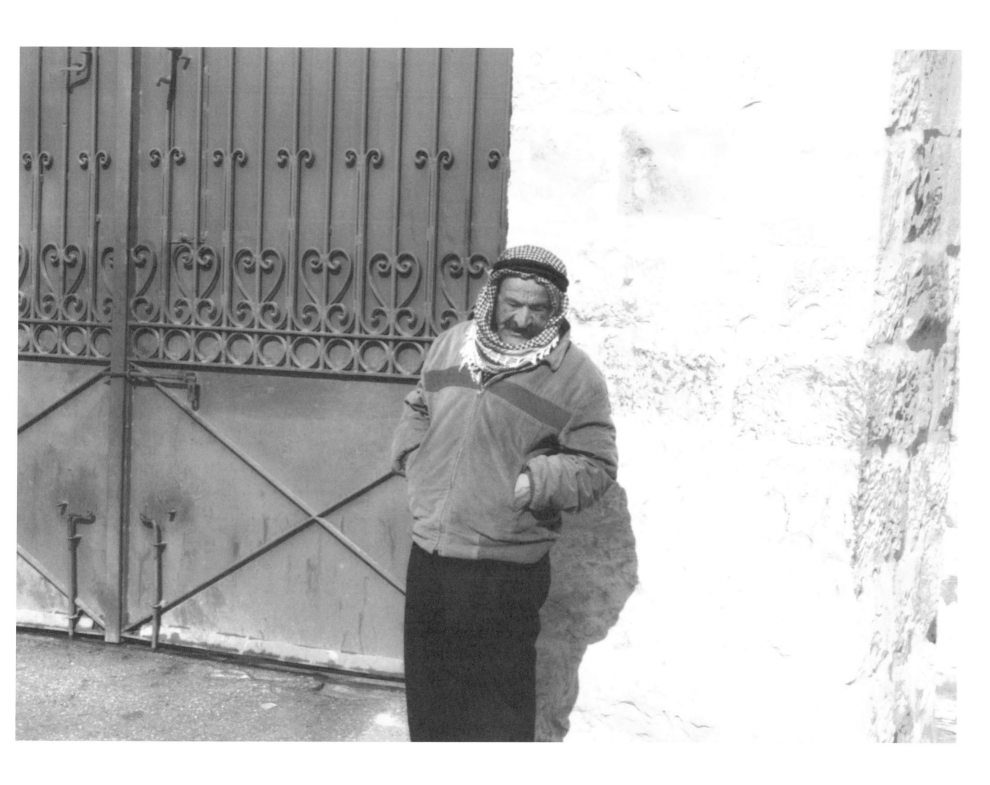

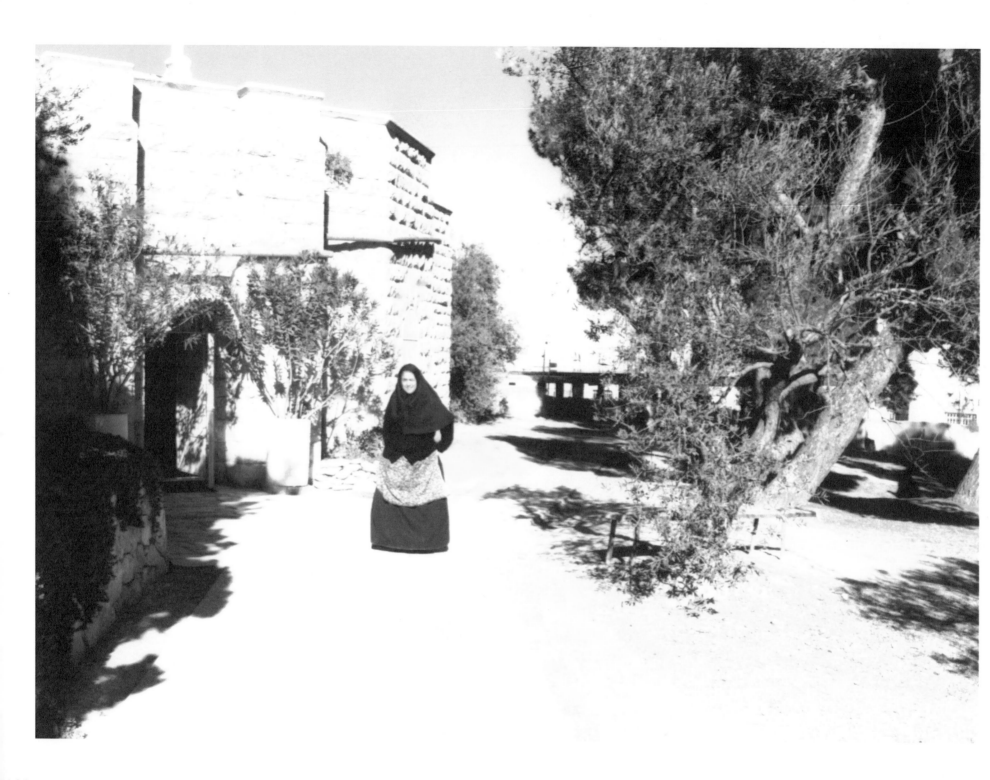

Handcrafted card made from real flowers by Sister Christina.

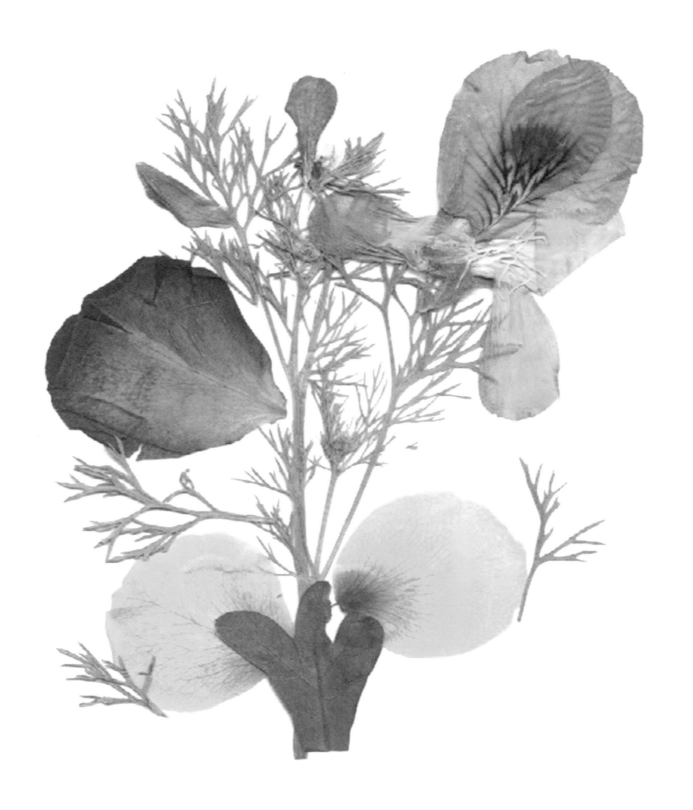

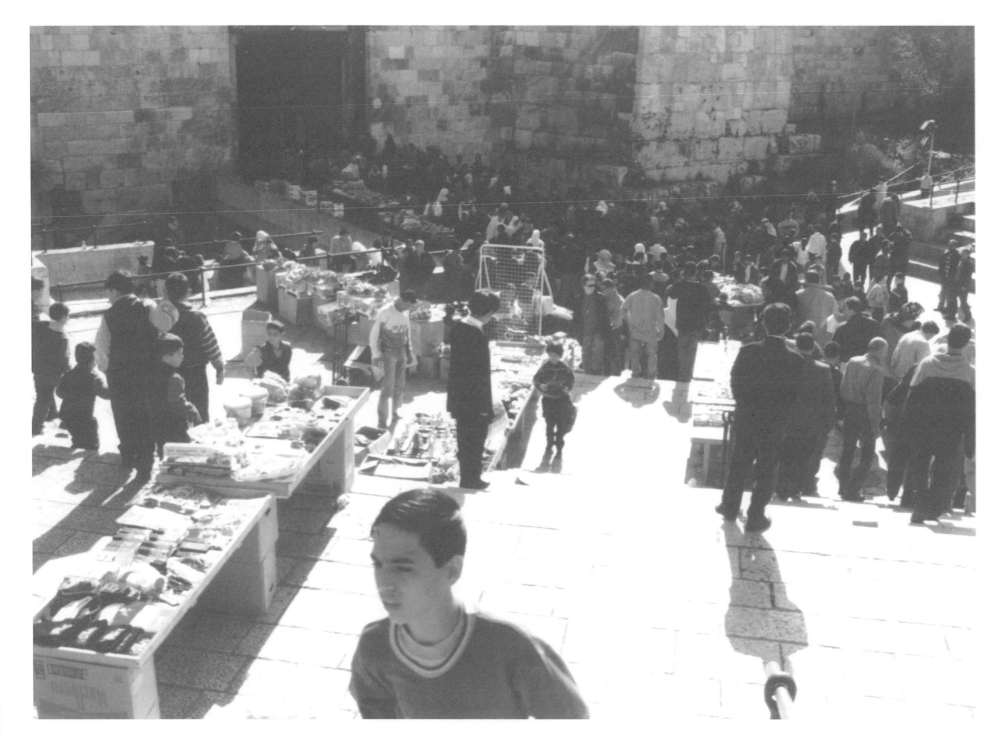

DAMASCUS GATE, JERUSALEM

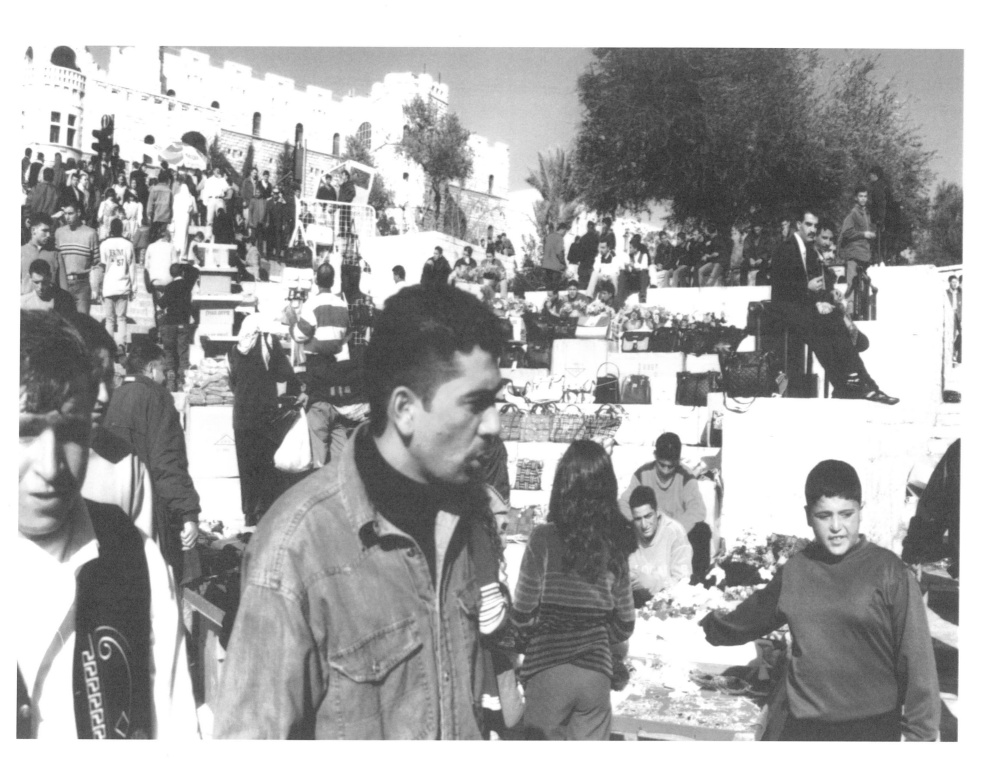

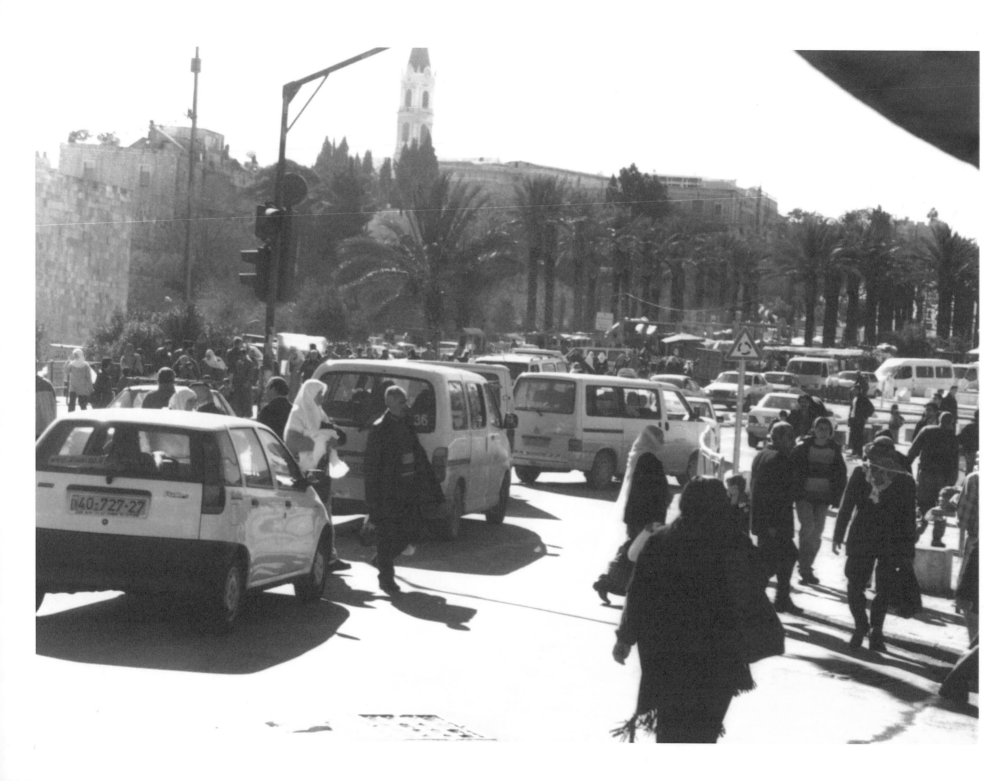

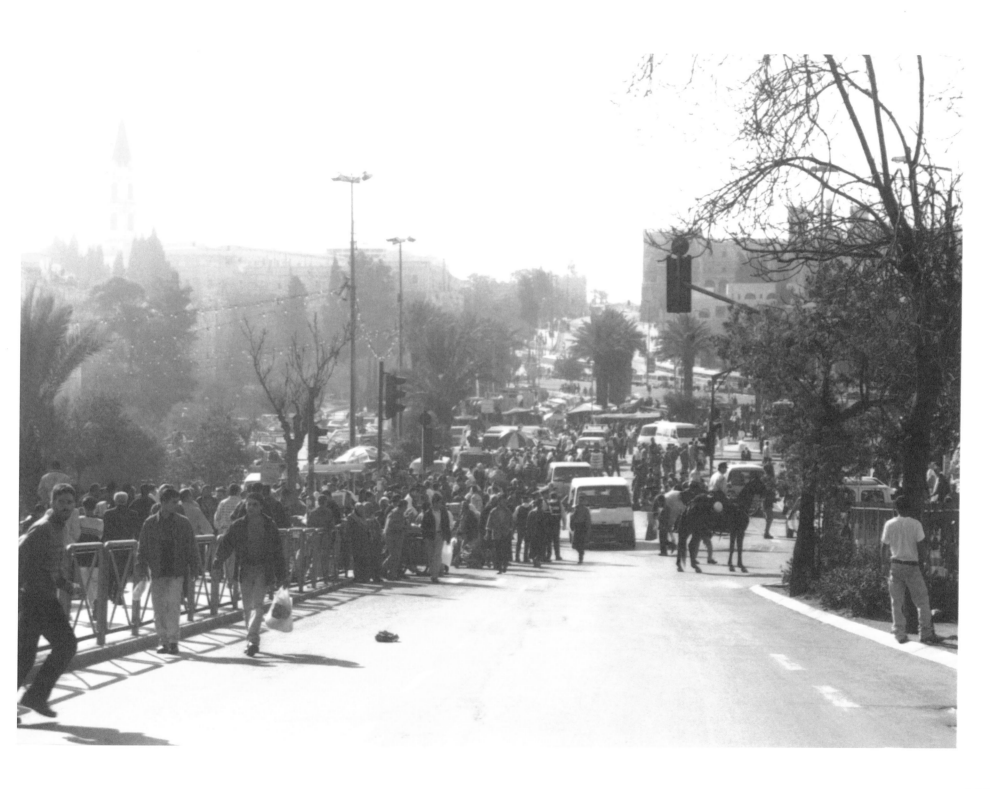

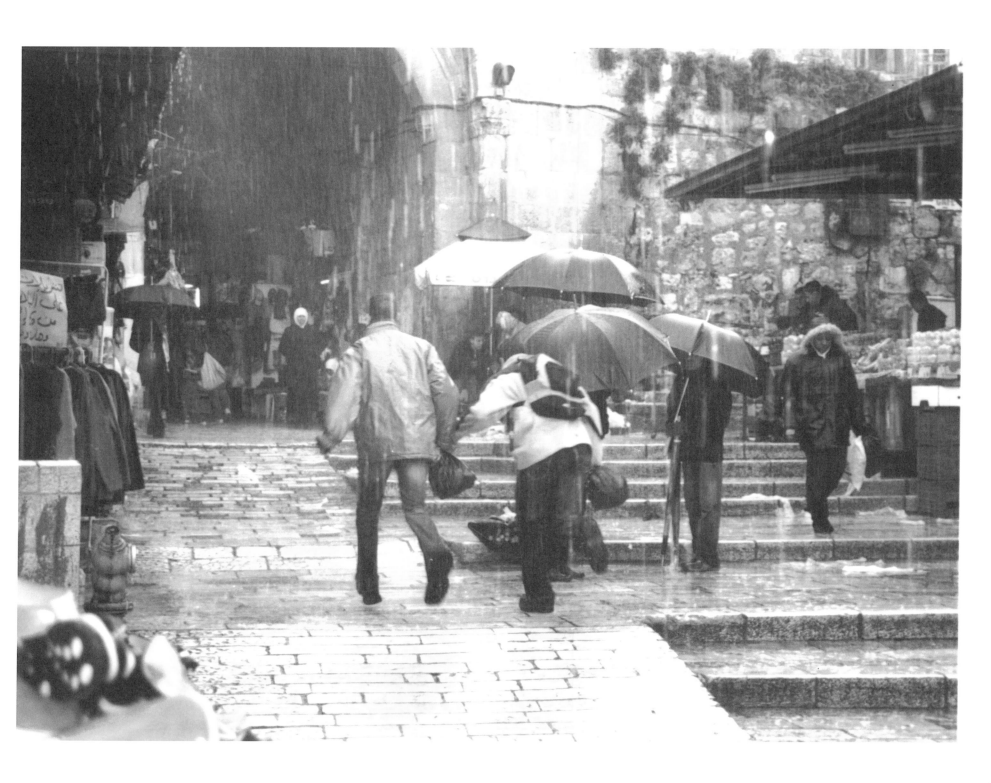

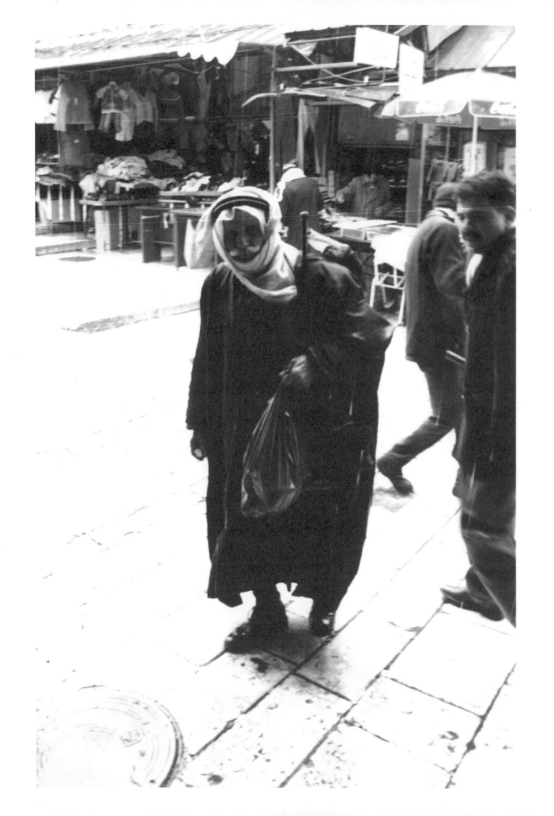

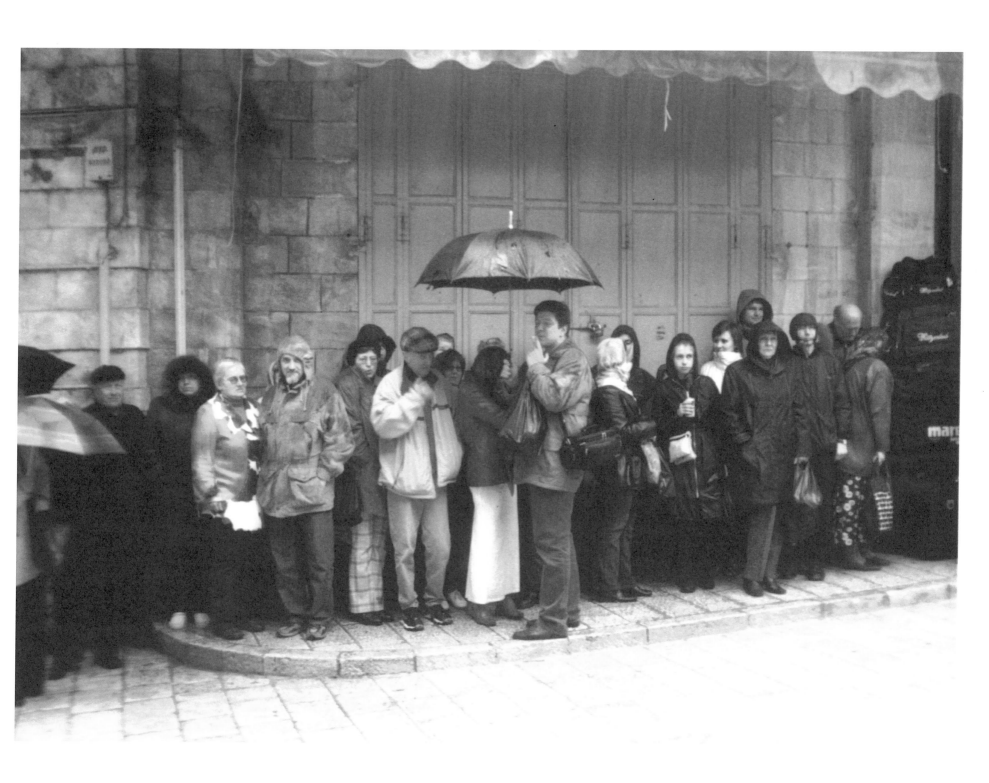

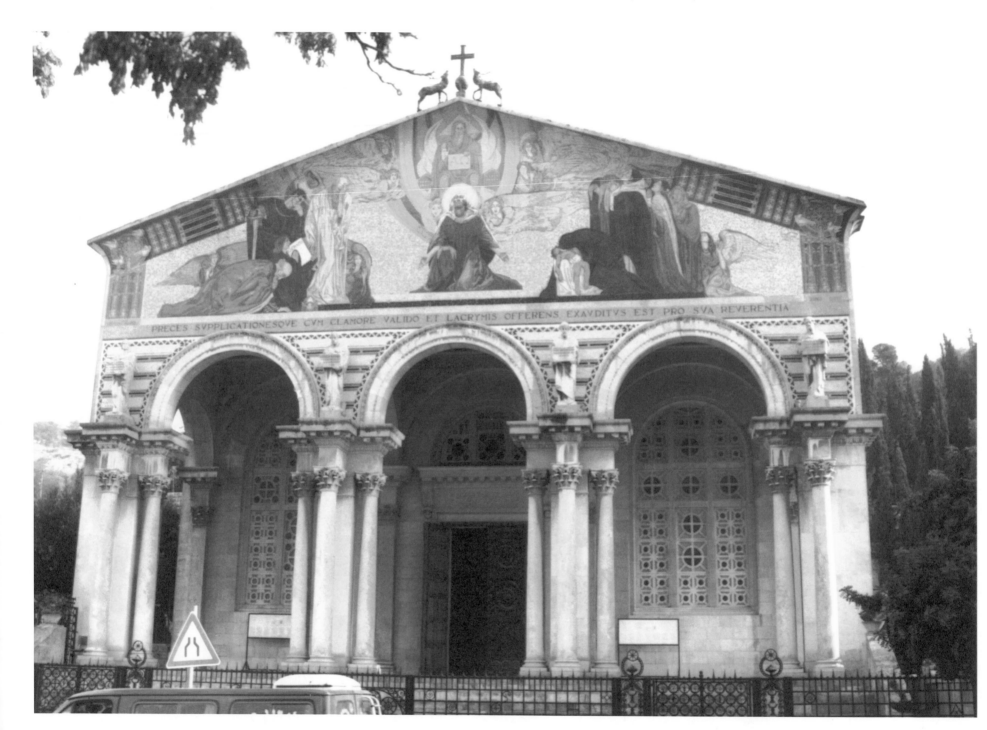

CHURCH OF ALL NATIONS, MOUNT OF OLIVES

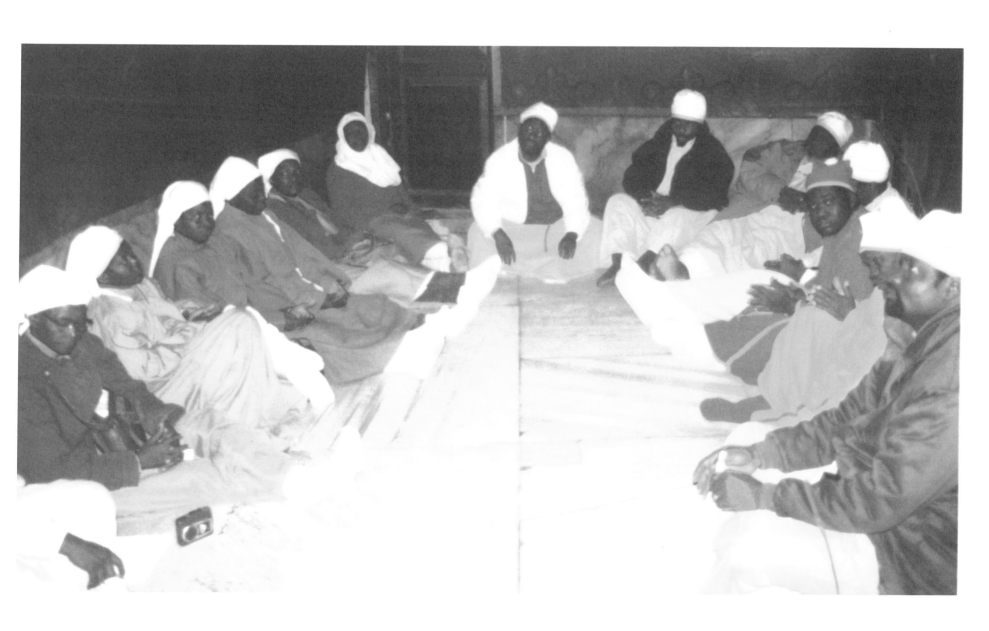

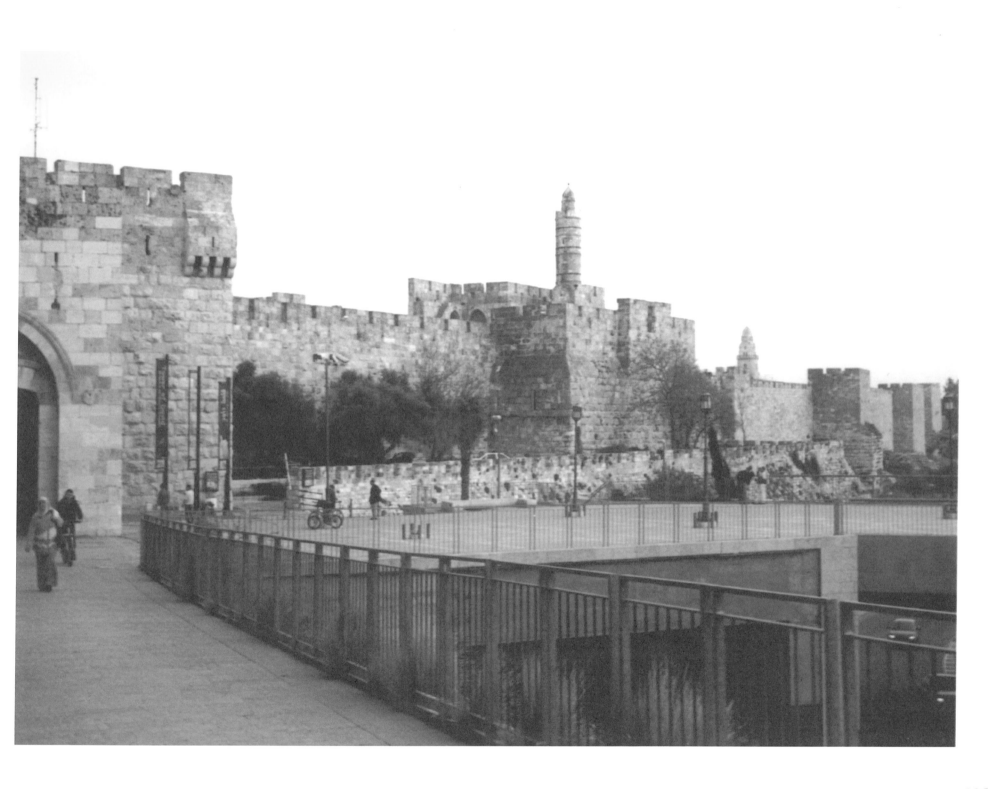

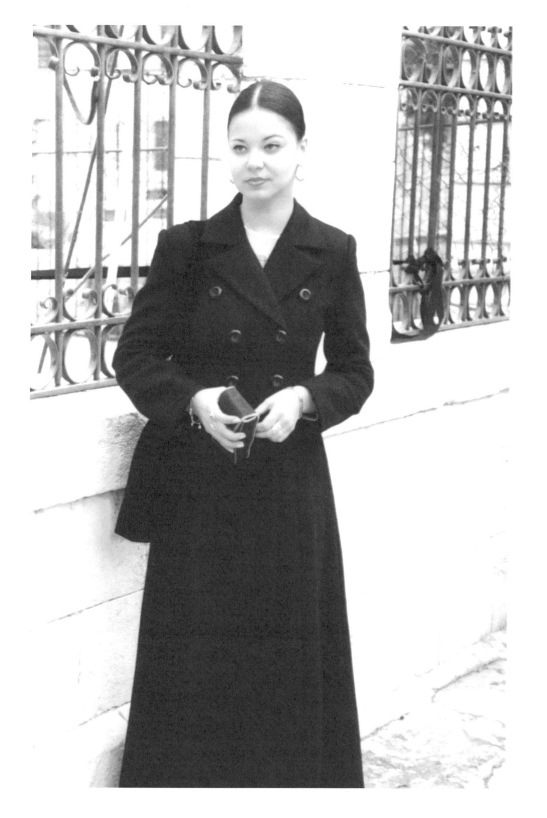

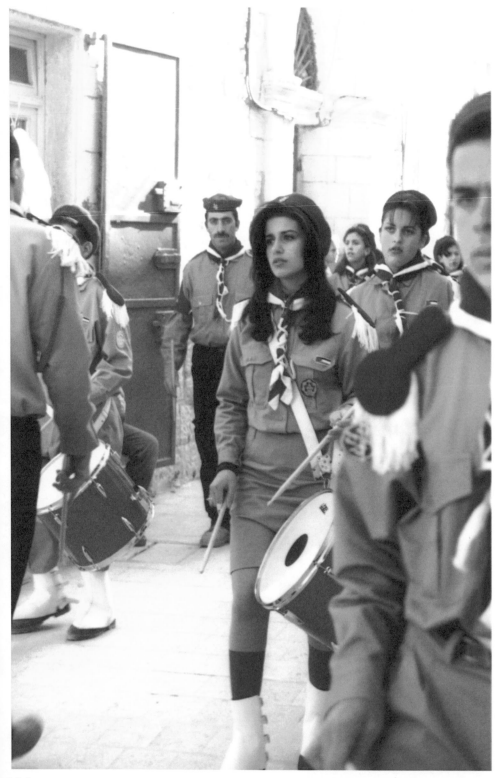
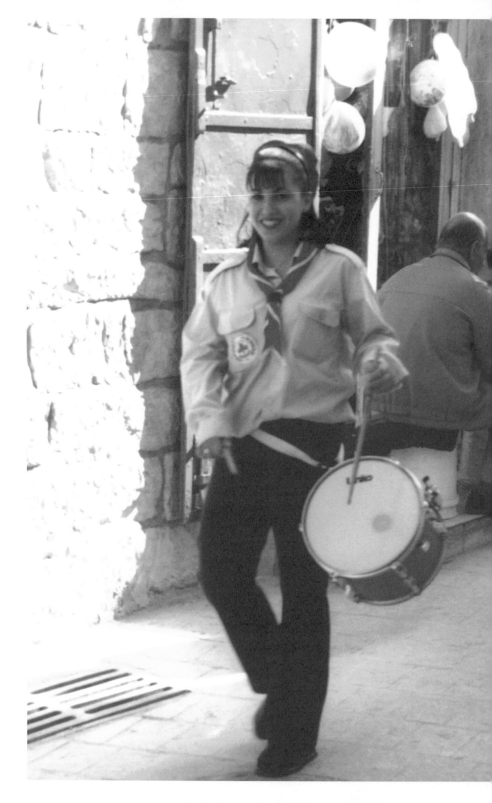

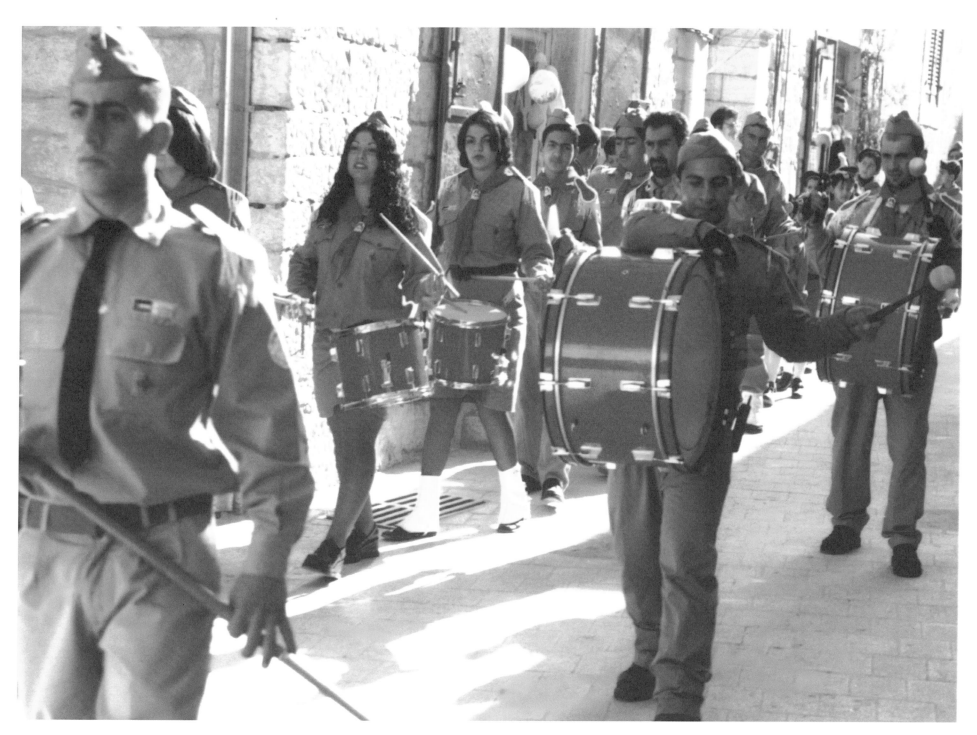

A marching band celebration in Bethlehem. Christmas - December 1999

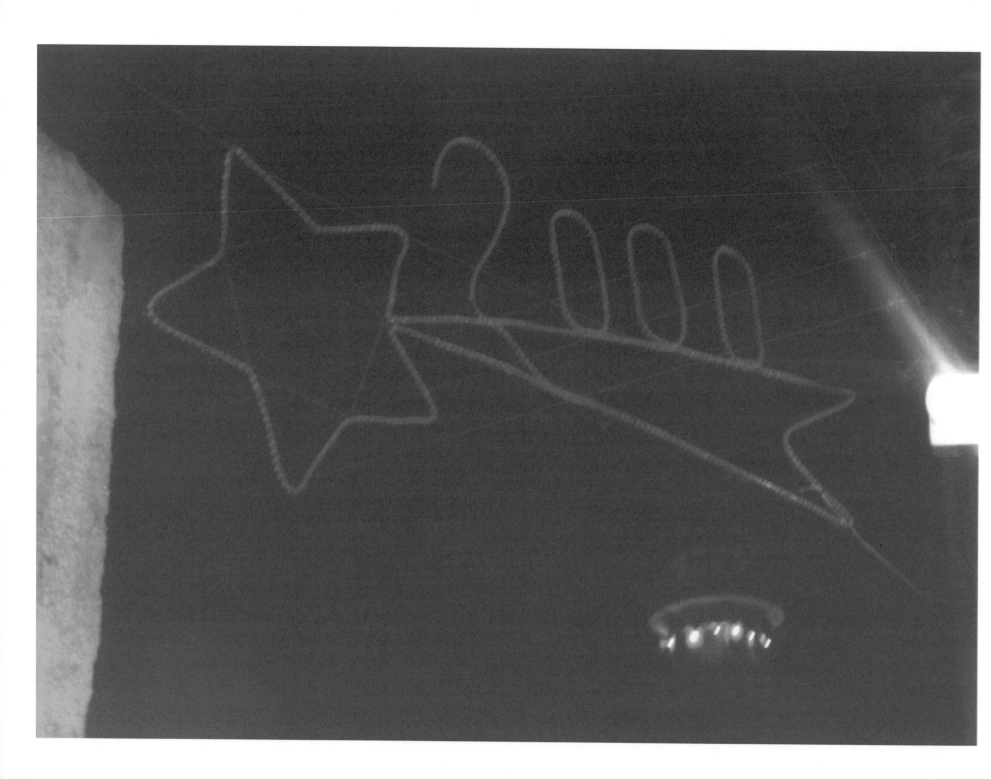

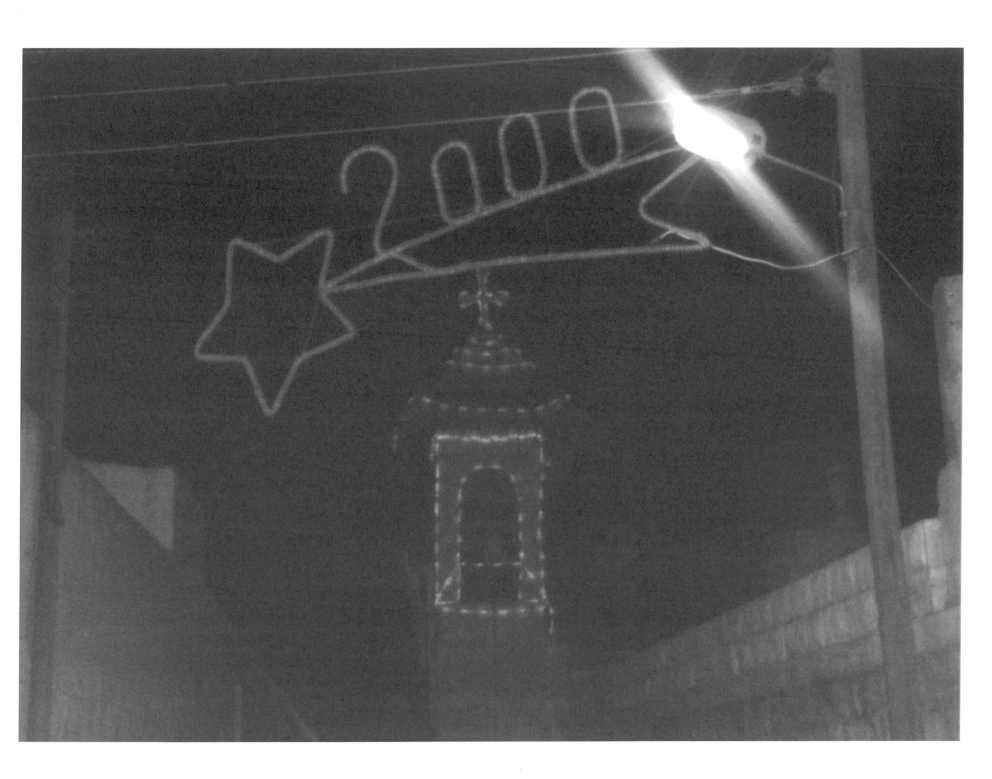

NEW YEARS CELEBRATION GOING INTO THE MILLENNIUM.